The Echo of You

The Echo of You

A Love Tethered Across Time and Space

Tammy Rébéré

ISBN: 978-1-7389954-0-0 (SC)
ISBN: 978-1-7389954-1-7 (HC)

First edition: 2023

Tammy Rébéré
Box 412
Ryley, AB T0B 4A0
Canada

www.tammyrebere.com

Distributed to the trade by The Ingram Book Company.

For my other half

TABLE OF CONTENTS

TABLE OF CONTENTS

TABLE OF CONTENTS

A NOTE TO READERS

*H*ave you ever met someone and just knew they were the one? *The one?* Your other half, your twin flame, your soul mate, whatever you want to call it— the one you absolutely beyond a shadow of a doubt knew they were the only one for you. You know this because they compliment you in every possible way. They are the yin to your yang. The familiarity is so strong you're positive you must have shared numerous lives with them already. Everything you feel with, and about, that person is like an echo, resonating and reverberating across time and space, hitting you to your very core.

But what if you couldn't be together? Sometimes there are reasons. Life can be complicated that way. Could you be satisfied in just the wanting?

What if you were able to be together and then for some reason you lost them? Could you go on knowing you lost the love of your life?

For hundreds, even thousands, of years, people have been fascinated with couples that are meant to be: Romeo and Juliet, Catherine and Heathcliff, Antony and Cleopatra, even Ross and Rachel. One way or another, they must find a way against great obstacles to be together, and if they can't in life, then they will find a way in death. It is their destiny. And as proverbial moths to a flame—or twin flames in this respect—we cry their tears, experience their pain, feel their passion, and exult in their triumphs. We want what they have.

To belong to someone, to be tethered to them, is a feeling like no other. It's as though you are a kite in the wind. It is exhilarating, powerful, scary, and dauntingly beautiful. It is worth the risk of being caught in a storm or carried too far by the wind, because no matter how damaged or lost you become, the ethereal tether can never be broken, and their echo becomes your beacon.

This collection of poems tells a sweeping and intense love story of a couple that is destined to be together. They meet through their dreams in the veil of the night guarded by the moon, but these secret astral trysts are not enough for the lovers, and they eventually find each other in person. However, their lives are such that they cannot be together and they tragically lose their way. It is not until they overcome their own personal demons, experience a time of healing by connecting with nature, and learn to trust themselves that they find the happiness they are truly destined for in each other.

Every word in this book is from the deepest part of my

soul, and every poem was written with tear-stained eyes. Between writing late in the night and taking photographs—often in the wee hours of the morning to catch the rising sun—this labor of love has been almost three years in the making. Some poems came from my imagination, some from my dreams, and some from my own personal experiences. I will leave it up to you to decide what is what.

In reflection on my own life, I see that it has been one magical, incredible, tragic but beautiful poem. For is that not what life is? Are we not art in motion?

It has been my privilege to write it down and give it a rhyme.

With love,
Tammy Rébéré

May 2023

TETHERED

&

BOUND

The convergence

of two stars,

tethered and bound

across time and space,

is but a kaleidoscope of

incandescent beauty.

And of tragedy.

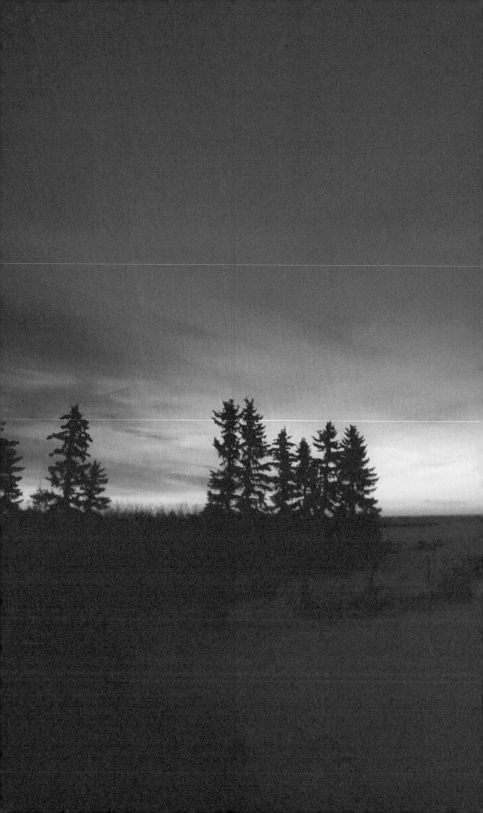

In the deepest, darkest
shadows of the night,
you found me
by the light of the
crescent moon.

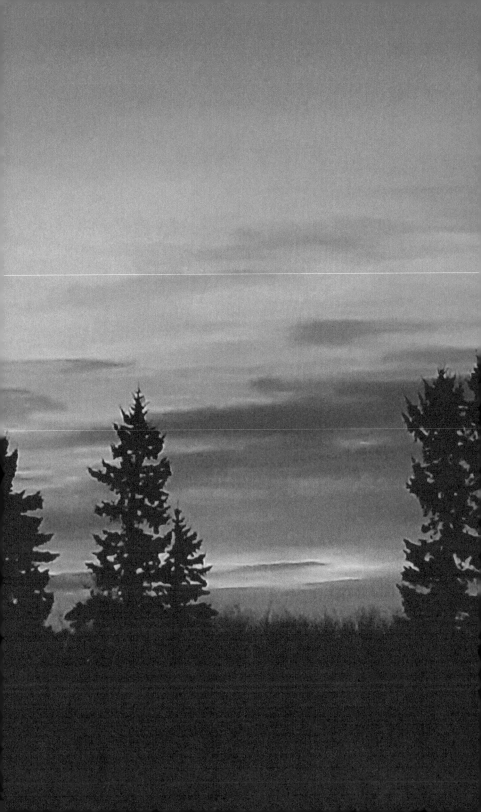

My Protector

Conjured to his mind as he drifts,
I'm the one in whom he confides.
Hearing his fears, his hopes, his dreams,
I hold and soothe him when he cries.

An illusion of his wishes,
I am real for a brief time.
Then returned and bound to my chains,
By the sound of the clock chime.

My voice brings him pleasure
As we talk through the night.
Discovering much of ourselves,
And in the dark, we find our light.

An illusion of his wishes,
I am real for a brief time.
Then returned and bound to my chains,
By the sound of the clock chime.

His heart is real, genuine, and pure.
I feel it in his pulse when I'm there.
The rhythmic beat against my breast,
As he combs his fingers through my hair.

An illusion of his wishes,
I am real for a brief time.
Then returned and bound to my chains,
By the sound of the clock chime.

In my chains I beg to be beckoned.
But held by forces beyond our control.
Released only when he calls,
Am I allowed to escape past the patrol.

An illusion of his wishes,
I am real for a brief time.
Then returned and bound to my chains,
By the sound of the clock chime.

Never wanting anyone else,
To each other we belong.
Dancing under the crescent moon,
Entwined in the music of our song.

An illusion of his wishes,
I am real for a brief time.
Then returned and bound to my chains,
By the sound of the clock chime.

He vows to never wake,
And we search for places to hide.

Fighting against the evil forces,
He keeps me close to his side.

An illusion of his wishes,
I am real for a brief time.
Hunted to return to my chains,
By the sound of the clock chime.

His love for me is undying.
They cannot tear me from his arms.
With him I am protected,
And will never be brought to harm.

An illusion of his wishes,
I am real for a brief time.
I no longer return to my chains,
By the sound of the clock chime.

In the morning with him I wake,
Sharing my hopes, my dreams, my fears.
In him I now confide,
And together, we soothe our happy tears.

A reality of his wishes,
I am real for all time.
We are bound together by our love,
By the sound of the clock chime.

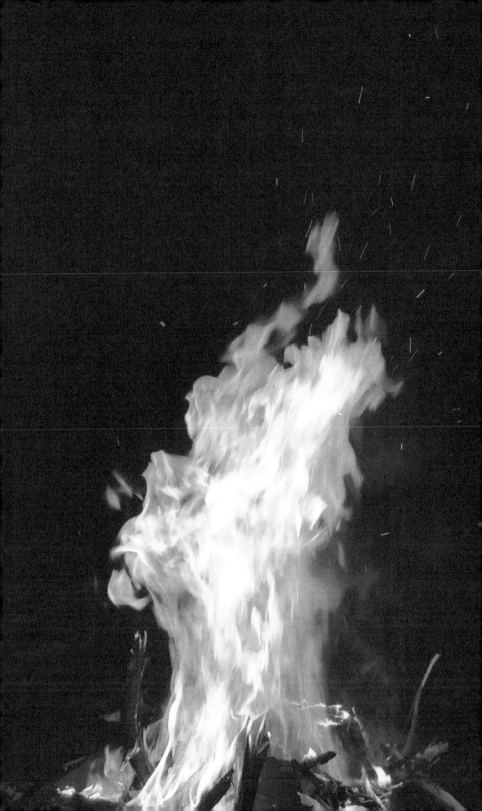

Eternal Flame

There exists a fire calling to me—
A familiarity I've not known.
It burns a path deep in my soul,
Lighting a way for me alone.

In my mind soft whispers echo,
"You know me and my name.
Your heart will find me soon,
For I am your love, your eternal flame."

The path is filled with treachery—
Darkness, angst, deceit, and sorrow.
If it were not for the burning light,
I fear I might not see the morrow.

In my mind soft whispers echo,
"You know me and my name.
Keep enduring my dear one,
For I am your love, your eternal flame."

The longing I feel keeps me going
To find the one that beckons me.
Through turmoil this course I stay,
Coming closer to my destiny.

In my mind soft whispers echo,
"You know me and my name.
Let the fire light your way,
For I am your love, your eternal flame."

His voice is my constant companion,
Reassuring all my fears.
With determination I continue on,
Searching for him through my tears.

In my mind soft whispers echo,
"You know me and my name.
Look to me as your strength,
For I am your love, your eternal flame."

As the path comes to its end,
The fire burns out of control.
Weakly, I fall to the ground,
For the journey has taken its toll.

In my mind soft whispers echo,
"You know me and my name.
I'm right here in front of you,
For I am your love, your eternal flame."

From the midst of its hot center
Emerges the one I am destined for.

Kneeling down he holds me close,
Vowing to never let go forevermore.

In his ear I softly whisper,
"I know you and your name.
Our hearts are beating as one,
For I am your love, your eternal flame."

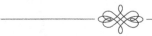

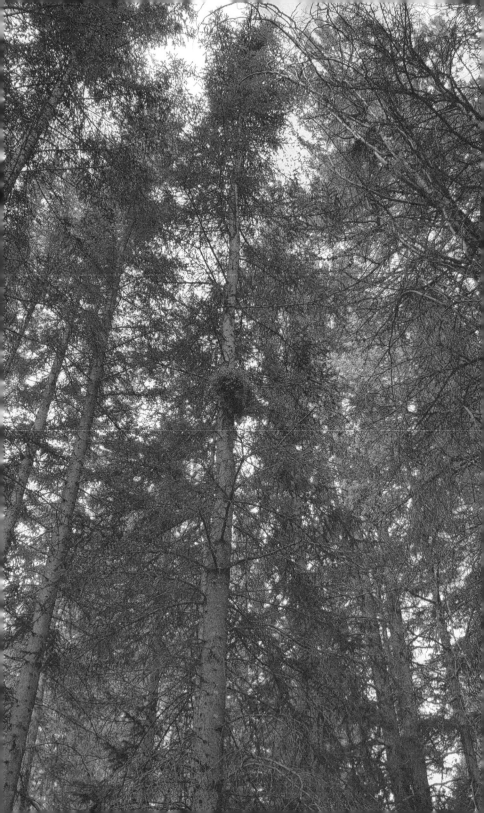

Rise

Standing in the forest, screaming to be heard.
In want of belonging, but left feeling absurd.
All around, leaves fall from the trees,
Whispering their voices, carried by the breeze.

Crying in the dark in the dead of the night.
Wishing the stars to shine, just a bit of light.
Thirsting for water to cleanse my shadowed mind.
It's beyond my grasp, and I'm stumbling blind.

Reeling in anguish, I fall, and fall, and fall,
Slipping through cracks, ashamed and small.
Alone in the forest, my form limp to the ground.
My soul aching for the one I am truly bound.

Comfort arrives as my mortal body sleeps
To the world beyond my own, faraway, and deep.
Light and color shimmer around the great expanse,
With waters gracing the shore in a rhythmic, sultry
dance.

My cries had been heard, for I was beckoned here
By the love of my life whose power erases my fears,
Unraveled and undone, I am drawn to his light.
For in his presence there are only pleasure and delight.

Breathlessly hungering for him to fill my soul,
The ecstasy that rages has me out of control.
My wildly beating heart pulses as one with his,
And I release myself upon him in waves of utter bliss.

Weakened and fragile, I lay in the power of his arms,
Protected by his love, absolute and without harm.
Not wanting to leave, I hold tight to his chest.
His whispers soothe my mind, bringing my heart to
rest.

Waking in the forest in the plight of my reality,
I rise as the phoenix with his fire sustaining me.
No longer alone, I feel his strength, his reach,
Pulling me back when I need to his faraway beach.

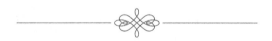

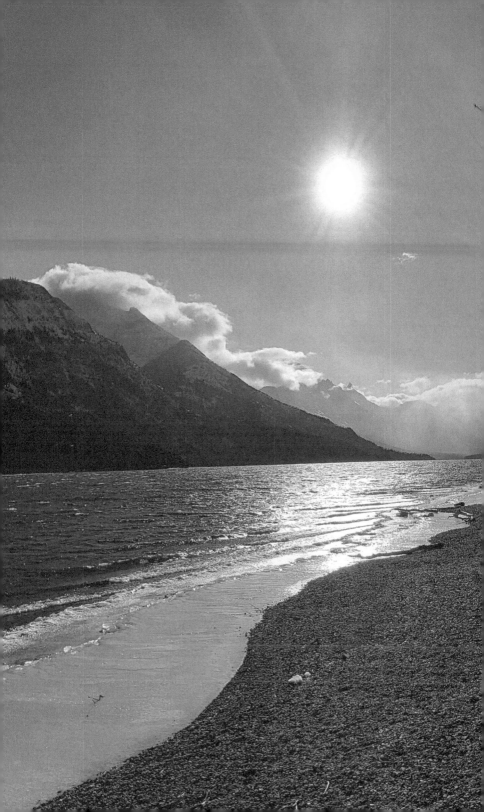

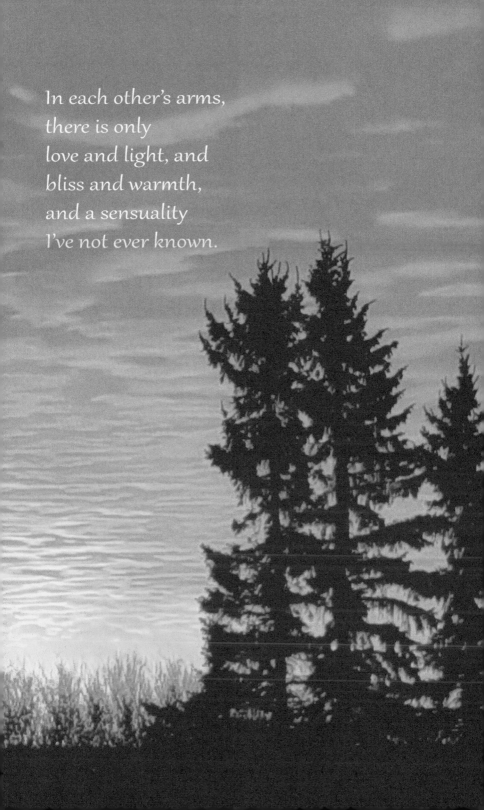

In each other's arms,
there is only
love and light, and
bliss and warmth,
and a sensuality
I've not ever known.

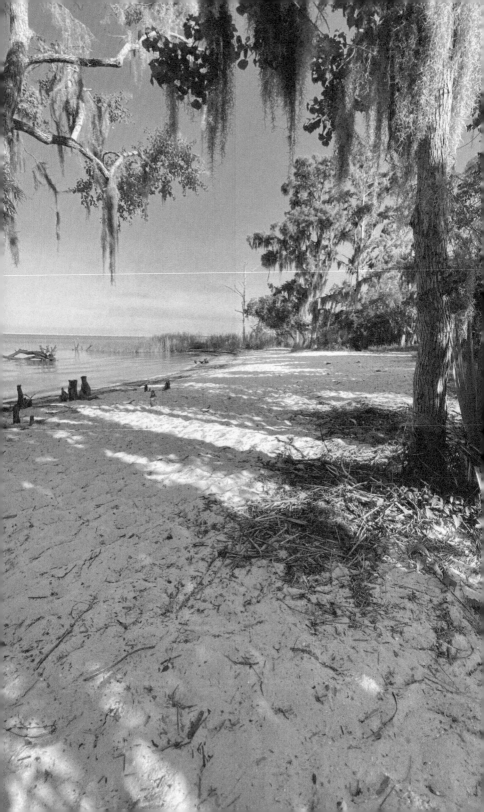

Crescent Beach

The cool night air brings a taste that is sweet
As I feel the grains of sand beneath my feet.
The warmth of the earth wraps around my toes,
Blanketing the depth of pain my heart only knows.

Aware of the barrier that keeps us apart,
I suffer a hole that aches in my heart.
The touch of your fingers overtop of mine
Fuels a simmering fire, stopping all of time.

Lost in your eyes, your longing I see.
I linger in the moment imagining you with me.
Our fingers entwine in a dancing caress.
You pull me close, my heart to your beating chest.

Guiltless we stay without any judgment cast,
Hoping our embrace will forever last.
Upon the open water a crescent moon shines,
Sparking a magic for our flames to now align.

I feel

the power

of you

in the deepest

of things

I put my

eyes on.

Haunted

My soul hears the breath of your whisper,
But my body aches for your roar
As the waves of the Atlantic ocean
Beg for the sandy, distant shore.

I am haunted by the depth of your words,
Forged in the shadows of the night.
Pulsating my heart into pounding echoes,
Until my skin shivers with delight.

My angst is my undying pleasure.
Living for you, my eternal fate.
Dreaming in want of your tender touch,
I awaken and impatiently wait.

The crescent moon pulls hard at my soul
Until my senses are enflamed.
I need your body entwined with mine
Because I am unleashed and untamed.

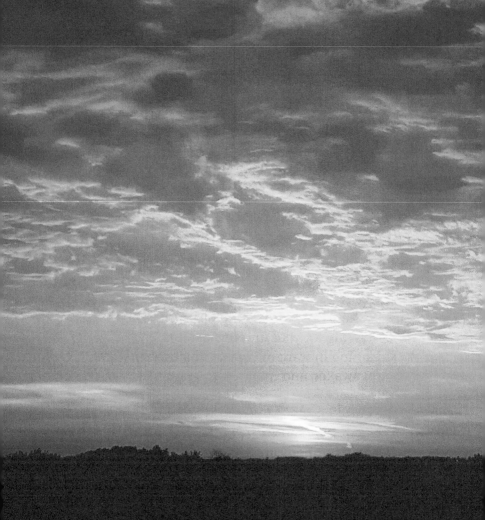

You are but a
fire-breathing dragon
intoxicating me
with your words,
setting my soul ablaze.

Dragons

There is within my soul
A monster hungry to be whole.

To feel alive, no more deprived—
A starving spine between my legs
And thine.

A ridge
That splits thy Appalachian breasts
In twine.

Oh, this timeless quest of mine . . .

Between the night and day,
I pine,
I pray,
And crave to crest that breast,
To ride or sleigh
This slave of mine.

TAMMY RÉBÉRÉ

Am I the slave?

Or is it bliss
That bends we men
To bow before that dip
That dips
between those hips
and lips?

I know but this:

To slay a dragon is no small thing.

And all of us are dragons in the end.

Aren't we?

My darling,

Let thy dragon
not be slayed,
but rather:

Bring your ridge
to my edge
and feast
your starving spine
within these legs of mine.

And hunger no more.

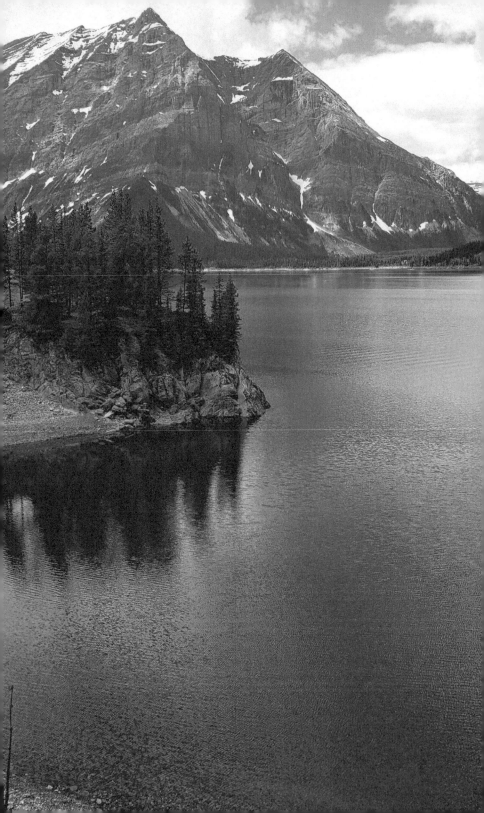

Transported

I'm with you baby
Wherever you go.
I'm always there.
Don't you know?

When I close my eyes,
I see your face.
The beauty of you
Cannot be erased.

I'm with you baby
Wherever you go.
I'm always there.
Don't you know?

When I sit quietly,
I hear you near;
The whispers of you
Inside my ear.

TAMMY RÉBÉRÉ

I'm with you baby
Wherever you go.
I'm always there.
Don't you know?

When I stretch my hand,
I feel your touch;
The caress of you
I need so much.

I'm with you baby
Wherever you go.
I'm always there.
Don't you know?

When I dream at night,
I'm in your presence,
Transported to you
By your essence.

I'm with you baby
Wherever you go.
I'm always there.
Forevermore.

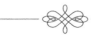

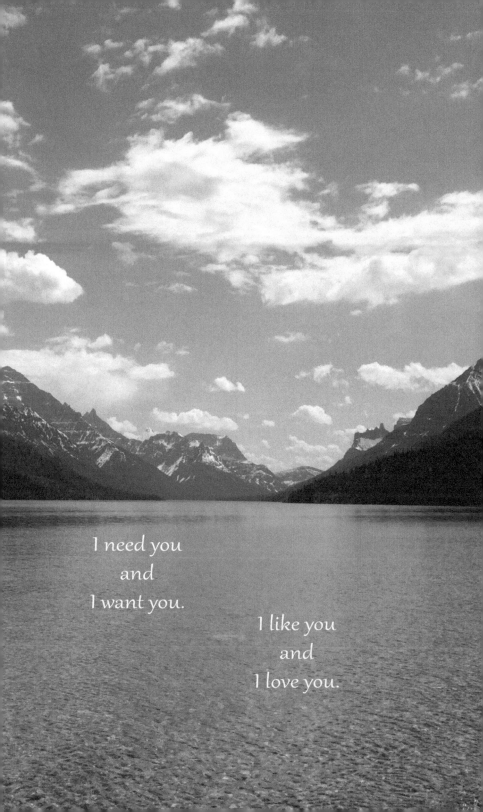

I need you
and
I want you.

I like you
and
I love you.

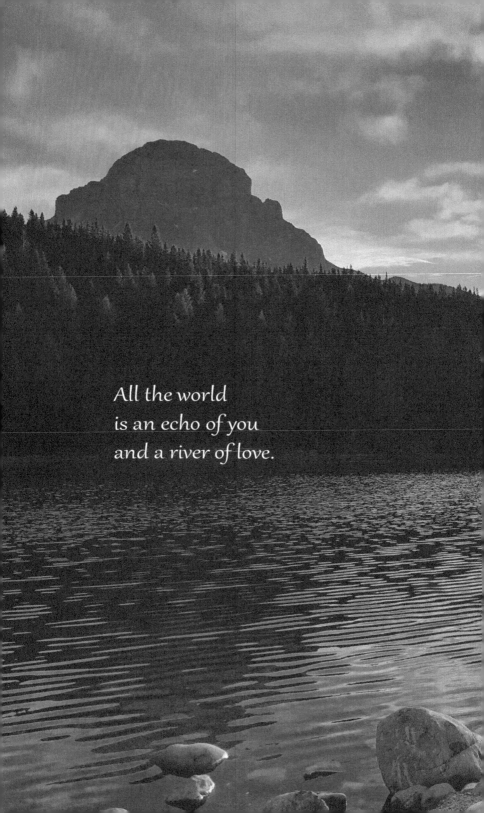

All the world
is an echo of you
and a river of love.

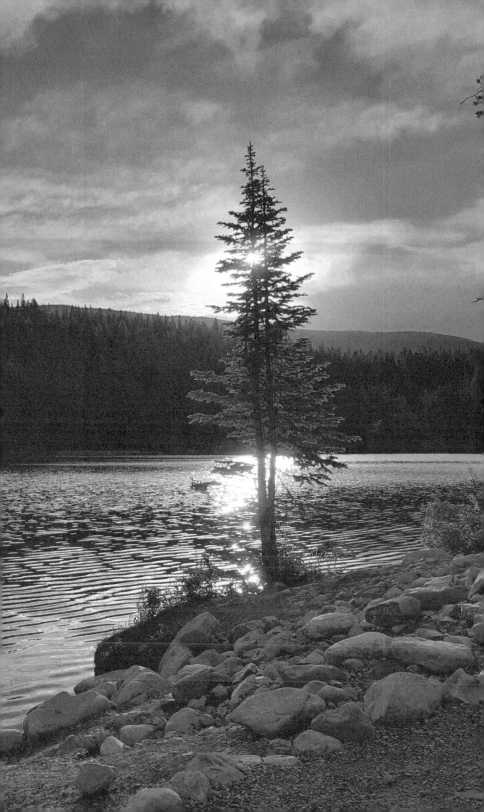

Golden Afternoon

From the branches of green leaves,
And the dappling shadows of breezy trees,
Outlining the path as we walk, and
Enticing our love to grow with tender ease.

The tip of your finger circling my palm
Arouses tingling shivers upon my skin
And intense pounding in my heart,
With my head in a free-falling spin.

You search for a place to be alone,
Beyond onlookers, hidden, and unseen.
Not far, you find the ideal spot:
A garden that is perfectly serene.

You guide me to a river of flowers,
And read an inscribed poem from above.
In this moment, we come to an awareness
From these words that deepen our love:

In the golden afternoon of summer sunlight,
We will not turn back, no, nor be still.
But rather, we will weave our melodious mark
Along our way, in bending to the world's will.

We walk and talk and dream
Of the future that we will come to build.
Then we bind ourselves to each other,
And our undying love becomes fulfilled.

of bending to the world's will

That Arizona sky
is but the taste of
sweet raspberry sherbet
of you
upon my lips.

I Know

I know your touch.
I know your skin.
I know your body—
The feel of you within.

I know your sound.
I know your sigh.
I know your whisper,
And what makes you cry.

I know your thoughts.
I know your mind.
I know your heart,
And why you're so kind.

I know you, baby.
I know your desire.
I know you want me.
So darling, let's create a fire.

You said,
"I wanna make
you messy."

I replied,
"Give me
your seed, baby."

Bound

With tilted hips and hair wrapped hands,
I am under your control—
Feeling your body,
Knowing your soul.

With a stroke of a teasing tongue,
I gasp with a moan—
Hungering, tantalized,
Wanting to be known.

With the caress of strong hands,
I am put into place—
Waiting, expecting,
Watching your face.

With the intensity of eyes,
I am endlessly found,
And in the throes of passion,
Forever bound.

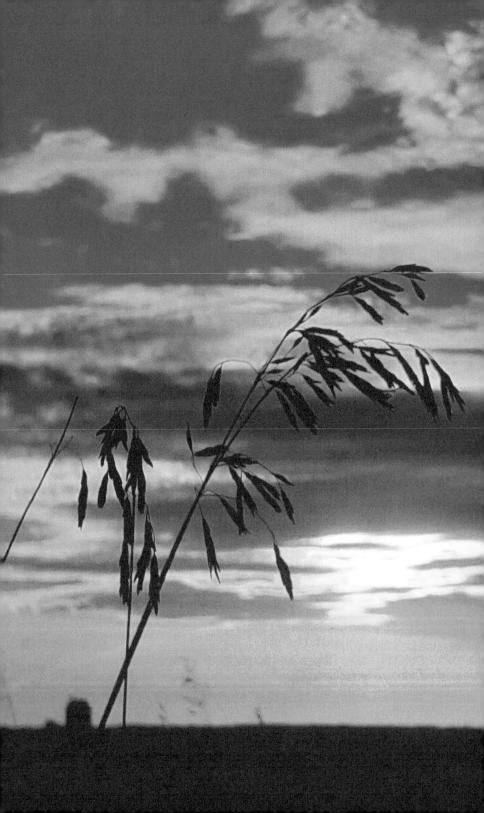

The Echo of You

Hmmm, the taste of your lips
As you arrange my hips,
With waves of bliss
From the sweetness of your kiss.

The intensity of your gaze,
Leaving my heart ablaze,
With the release of you
Forevermore binding us two.

The giggles and laughter
In between the hungers of our pleasure,
And deep discussions, naked,
While eating sandwiches in bed.

The bar we snuck into
To hide from the world,
The poem we read,
The piano you played,

The dance we shared,
The scars we touched,
The smiles we had,
The tenderness,
The fire,
The alignment (in any position).

We heal the broken in us
With no end to our love.

And when I'm not with you,
I feel the echo of you.

There was nothing
more beautiful
than when you
kissed my scars,
and nothing
more perfect
than when
I kissed yours.

I am but

a canvas, stained

and imprinted

by the

sweeping

echo

of you.

Life feels so unstable,
and yet
the future version
of me
and of you
needs the current version
of both of us
to be strong,
and brave,
and soaked
in kindness.

No matter what.

Burden

Your beauty is beyond belief with
Kindness shining from your core.
An iridescent glow wrapped about you
As you give yourself more and more.

The luck is mine to know you.
To be in your presence, to learn
About life and love and laughing
Has been my greatest concern.

We crossed a threshold of madness
And love we'd not ever known,
Giving ourselves to the other freely,
Expecting more light to be shown.

But now there's a weight upon you,
Keeping you up day and night.
Burning the candle at both ends,
Searching for ways to gain more light.

I'd give anything to make you happy
and help you be who you're meant to be.
But I fear the mass you carry
Is the heavy burden of me.

You are irreplaceable.
You are perfect.
You are incredible.
There is a hole
when you are gone,
and I am so
crazy grateful for you.

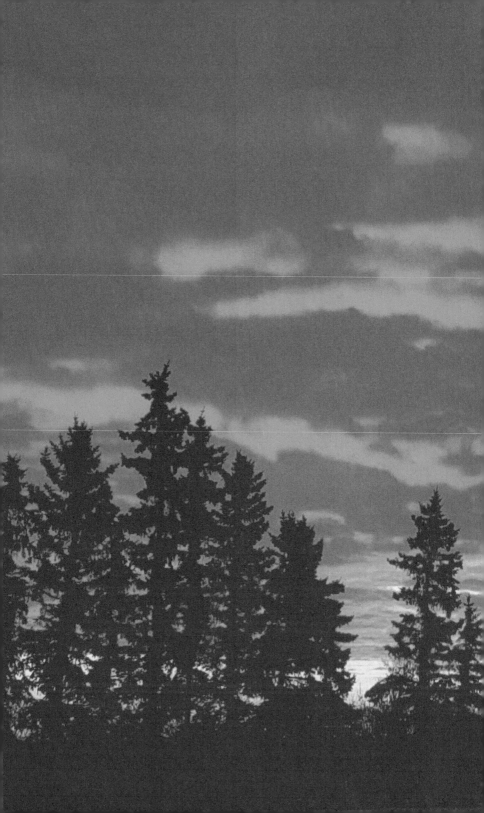

The Sacrifice

The visions I see
Are of you and of me,
With a beauty ahead
And a torment not said.
These are the burdens I carry
And the fears that I bury.

Our future is aligned
And also entwined.
But you have a path
That brings an aftermath,
And alone you must endure
For grace to secure.

This dilemma I face
Is mine to embrace.
Do I tell you what to do,
Even if I know it to be true?

Do I keep the visions inside
And help you as a guide?

It hurts my heart
Knowing the path you have to chart.
For a choice must be made,
And a price to be paid
To have the happiness you desire
And the life you aspire.

Whatever sacrifices need to be made,
I promise to not be afraid,
Supporting where I must
With my own path to adjust.
For you are my destiny,
However our future comes to be.

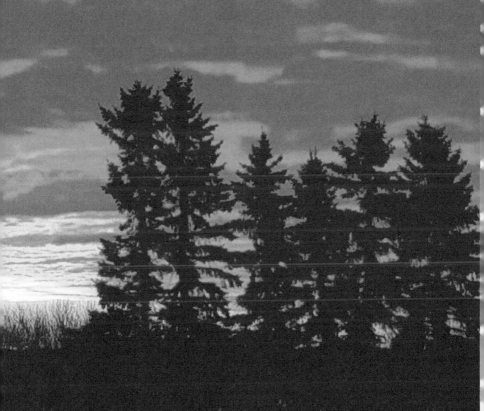

I will protect you,
much as the clouds
provide cover
for the sun,
and yet
let its glorious splendor
shine through.

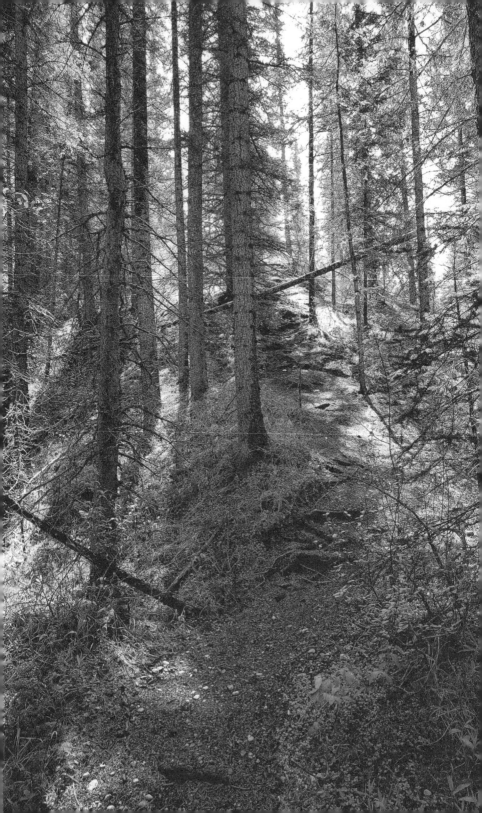

If Ever You Should Lose Your Way

If ever you should lose your way,
I promise to find where you are.
Across the ocean or across the land,
Even high up on a distant star.

There is nothing that can keep me from you,
For you are the love of my life.
From the moment we were bound,
I became your secret wife.

I belong to you, and you to me,
Even when we're apart.
The tether between us cannot be broken,
As it's attached to my heart.

Just use your compass, darling.
The magnet points to me.
I am closer than you know.
Close your eyes and you'll see.

We are always together,
By our love, tethered and bound.
If ever you should lose your way,
I promise you will be found.

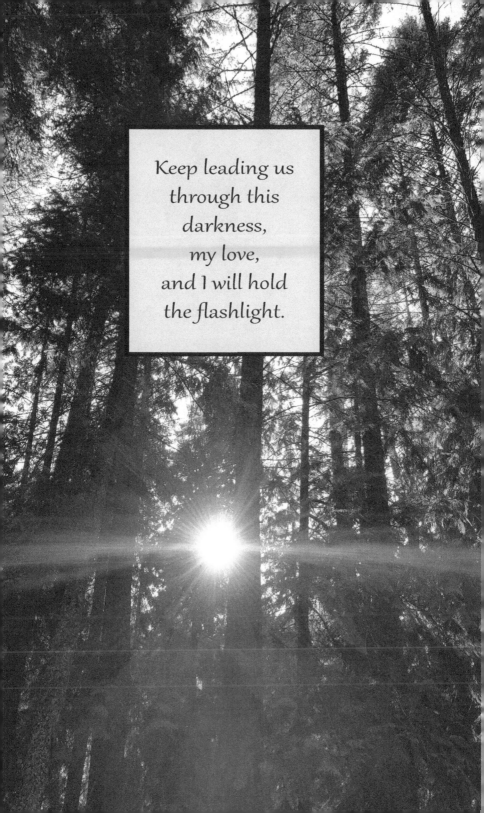

Keep leading us
through this
darkness,
my love,
and I will hold
the flashlight.

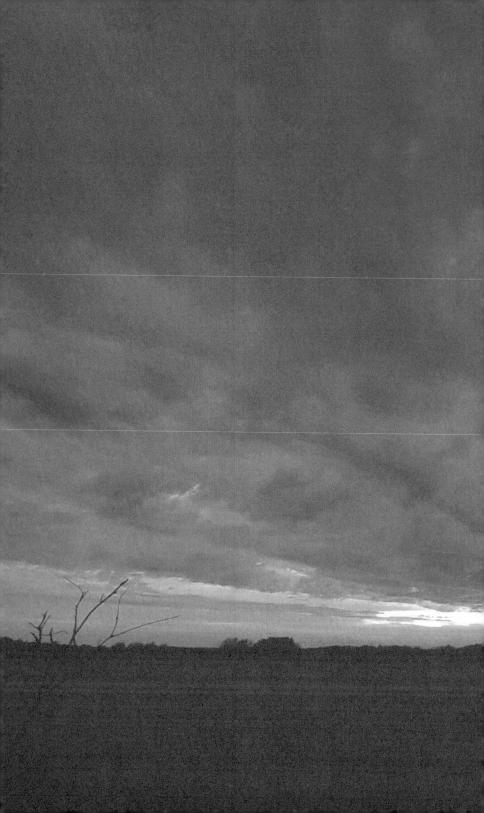

Some seasons

seem darker

than others,

but there is light

on the horizon.

The light is assured,

and it is beautiful.

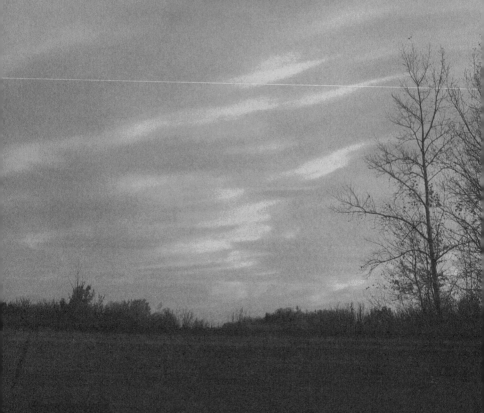

I belong to you,
and you to me.

Our ethereal tether
cannot be broken,
however lost
we become.

Tethered

Like a kite flying high in the wind
With the breeze flowing over my skin.
Higher and higher I fly to the clouds,
Peering down to the small distant crowd.

I'm basking in the sun yet crying in the rain,
Soaring through these clouds, trying to escape my pain.

Tethered to you as a chord of a sphere,
Your heart's rhythm is beating ever so near.
I'm pulled so close yet pushed too far.
Cast to the dark without even a star.

Searching for the sun but crying in the rain,
Soaring through these clouds, trying to escape my pain.

Scared and alone on this arduous flight,
Fully aware I created my own plight.
In love with one that is not my own,
I'll fly high and might never come home.

Wishing for connection but stuck in this rain,
Soaring through these clouds, trying to escape my pain.

This sphere is large, and I can't quite reach
You standing below on our abandoned beach.
Until the time the crescent is in sight
Will you find the strength to reel me with your might.

Soaring through the clouds with the magic of the moon,
I finally escape my pain and fall into you.

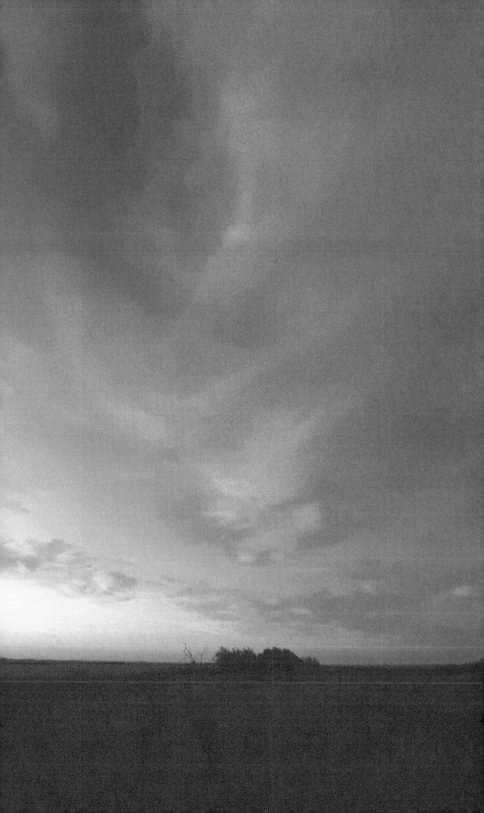

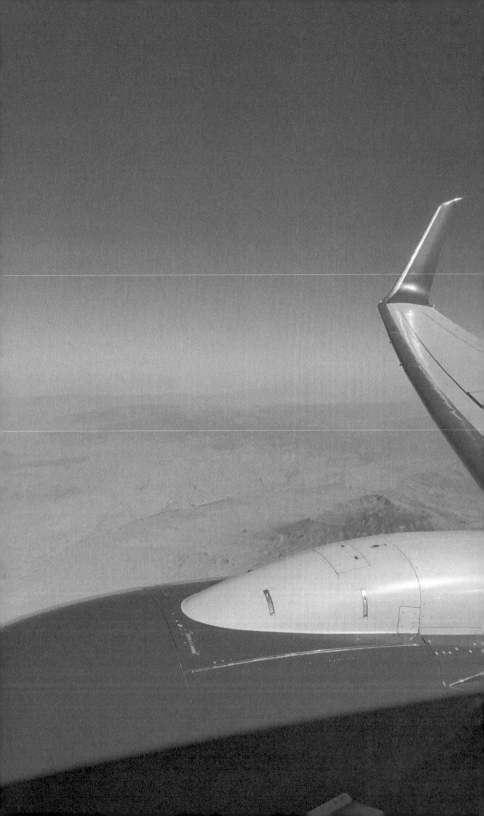

Colliding Worlds

Through the tears of a sleepless night, I worried—
Overthinking my manners, my speech, my place.
This pressure holds my heart hostage
In some kind of tortured embrace.

For this week I'm overwhelmed with loss,
But I must push forward with courage.
Alone on this flight, and alone in this world,
Because I'm not the one with privilege.

Worlds cannot collide without damage,
Even if they create something new.
So I will absorb all this pain
And keep it safely hidden from you.

I needed your voice as I sit on this plane,
But you failed me as a friend.
You're more concerned with your own world,
And my fears you refused to comprehend.

TAMMY RÉBÉRÉ

My strength is my ally.
It's all I've ever known.
And somehow through this day,
I'll find my way alone.

Life is
too short
to be unkind.

Our time
is precious,
my darling,
and fleeting.

And I love you
enormously.

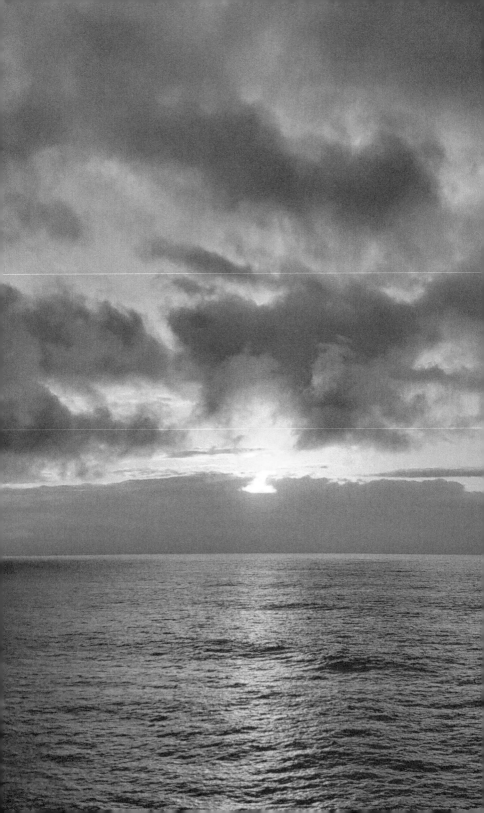

Waiting

Writing the words of my heart
Of the thoughts that tear me apart,
As the rain pelts on my soul,
Reminding me I'll never be whole.

The fire I once felt within
Is now but an ember so thin,
Waiting for the spark
To light up this dark.

I've been waiting for you,
For I know our love is true.
But your fear keeps you away,
And from me you always stray.

How long do I stay?
For all time? Come what may?
Or for as long as this rain pours,
Drenching me to the core?

I have nowhere to go,
Nor do I want to know
What keeps you from me
And why I'll never be free.

For we are tied, tethered, and bound,
And I keep waiting for even a sound
Of a future echoing from our past
To remind me: Our love is meant to last.

However long it takes,

I will still

be here for you

in the morning.

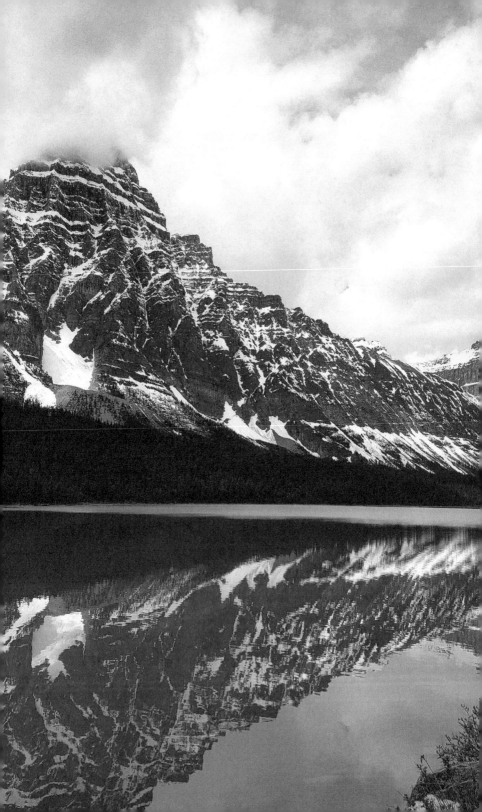

Don't Forget

Please don't forget the time we had,
Making love, passionate and mad.
From tender kisses upon my knee
Until your body enveloped all of me.

I cannot conjure the words to rhyme,
That can explain our place in time.
For it ticks and beats from your chest,
Where only my head can find its rest.

Please, oh please, don't forget
The memories we made since we met.
Promise to remember the echo of us,
And I promise to rise victorious.

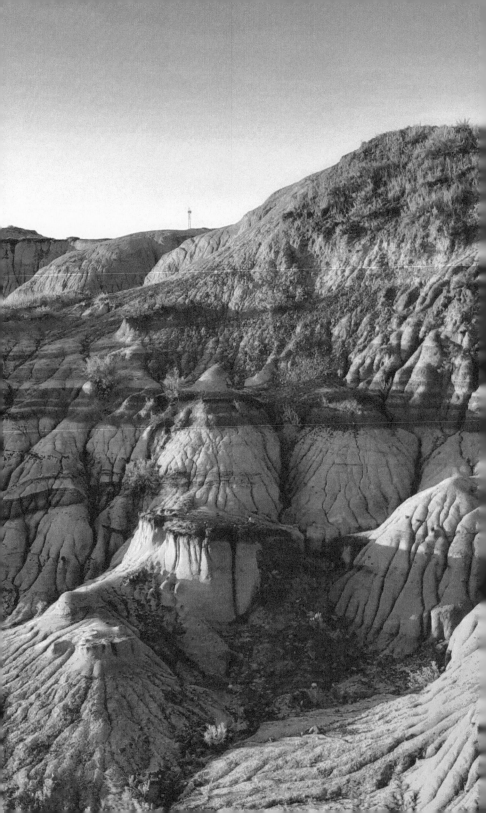

Drowning in a Drought

Your absence has me drowning in a drought,
With my hands outreached, grasping,
Begging for the water of your words,
But the dry parched air has me gasping.

I'm drowning in this drought without you,
Choking on drops sprinkled here and there.
Unable to grow, let alone flourish,
Sometimes wondering if you really care.

I can see the lake of your life,
Pooled with laughter and love all around.
But that is so far and distant from me,
Standing here on this dry cracked ground.

I'm taking you any way I can get you,
But it's barely keeping me alive.
I need to soak in your presence,
Quench my thirst and truly thrive.

One day we will have our time,
But I fear it might be too late.
For I've been drowning in this drought,
And soon will suffocate.

Rescue me with your rain.
Pour it heavy upon my doubts.
Flood me with passion and life and love,
And save me from drowning in this drought.

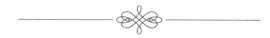

The world is
a lonely desert
without you.

I am so very lost.

I woke up

this morning

and didn't know

what to do

because you

weren't there.

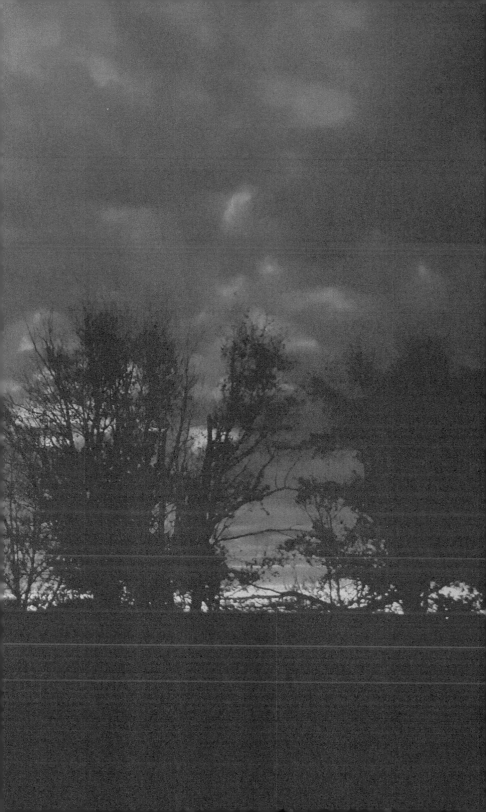

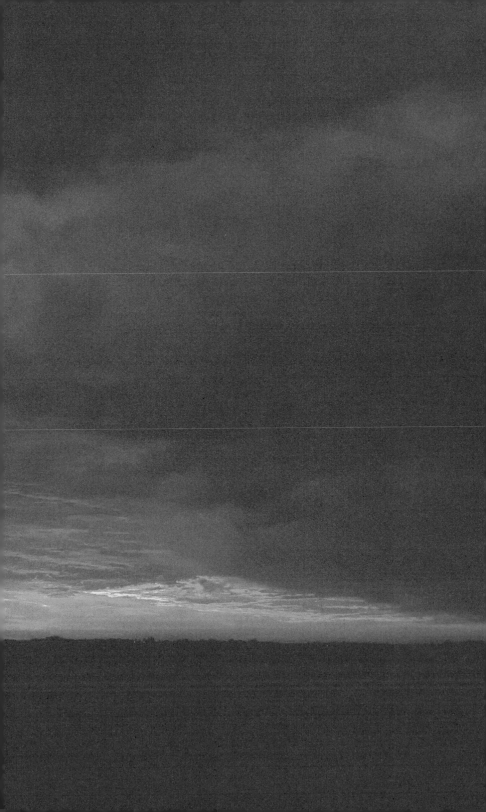

Looming Darkness

An iridescent prism encapsulated our love,
But my lack of judgment marred its beauty,
And a looming darkness has found me.

My heart continues to impale itself
From its own jagged shards.
I am deservedly lost for not shielding my love.
And your trust may never again be gained.

I will sit in this darkness and wait
Until you choose to shine your love upon me
Once more.

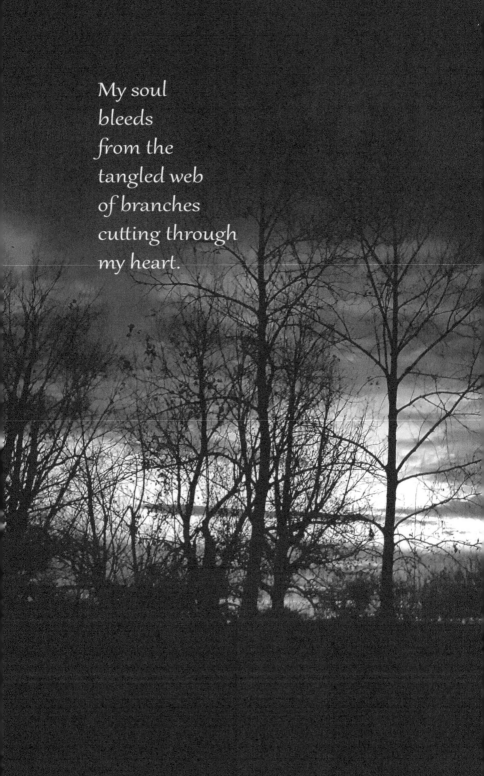

My soul
bleeds
from the
tangled web
of branches
cutting through
my heart.

Lost

Blanketed by a heaviness closing in on my soul,
I'm gasping for breaths and my tears start to stream.
It is dark all around and I can't find my way.
Please, oh please, release from me from this dream.

I'm lost in the forest with tangling trees closing in.
I'm scared and alone searching for the light.
But the night is black, and no stars can be found
To guide me through on this bleak, dark night.

There was a time when the sun followed me,
But it abandoned me like everything else.
I am undeserving of its beauty and warmth.
All the colors are gone, even the muted pastels.

No one is searching and I'm all alone.
Unworthy and unloved is how I'll stay.
I wish to God for just a bit of light, but
It is dark all around and I can't find my way.

LOST

&

FOUND

Tethered to the weaknesses

of the mind and flesh

is as gravity pulling

wind-tattered leaves

from trees

to the ground.

It is but a

blanket of death.

And of life.

I must find a path

through this darkness

—my darkness—

if I'm ever to discover

my light again,

and a second chance

of us.

But I feel so very alone.

Alone

I'm tired, so very tired
Of being alone.
Bring me peace, please,
To this life I've known.

Alone in my head
Is a bad place to be.
Too many thoughts
Replace the people I see.

Alone and unwanted
Is the life I live,
But many would say
I'm just being sensitive.

I need to sleep, but
I'm haunted there too
By the loneliness
That has become my issue.

TAMMY RÉBÉRÉ

I will drown
In the emptiness of me,
And bring a close
To this endless misery.

I am haunted
by the beauty
of what could
have been.

Skies of pink
and purple
are the
long-lost
dreams
of little
girls.

Her Little Song

Memories engulfed in flames,
Taking the home she only knew.
Left knowing only the shame
Is how this lost one grew.

The little girl whispers her song,
Looking for a place to belong,
Wishing for rights from wrong,
Having only her little song.

Moving from town to town,
Never planting any roots.
Feeling that she might drown
In this state of destitute.

The little girl whispers her song,
Looking for a place to belong,
Wishing for rights from wrong,
Having only her little song.

She stands in the noisy crowd
Alone, crying to be loved,
But she was never allowed,
And her emotions she shoved.

The little girl whispers her song,
Looking for a place to belong,
Wishing for rights from wrong,
Having only her little song.

In a language not her own
She sings a melodic sound
Of a creature also alone.
With him, she waits to be found.

The little girl whispers her song,
Looking for a place to belong,
Wishing for rights from wrong,
Having only her little song.

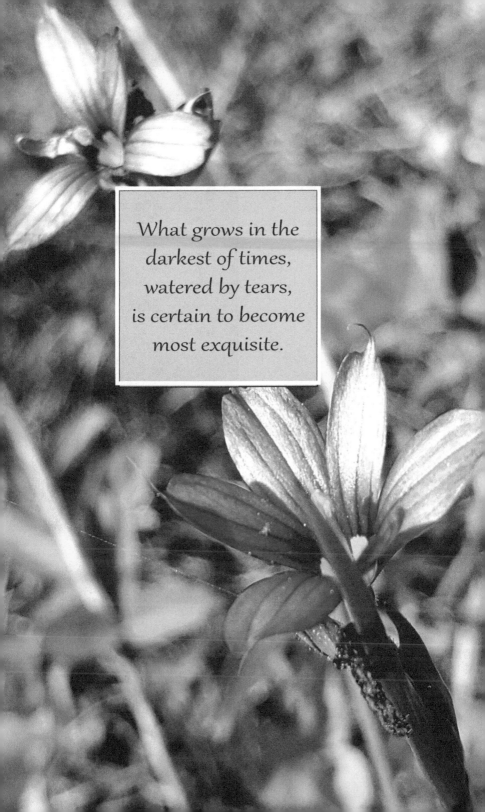

What grows in the
darkest of times,
watered by tears,
is certain to become
most exquisite.

MADNESS

must become me

because

I

MISS

YOU

like

CRAZY.

I Just Need a Breath

Before I reach my death,
I just need a breath.
A moment or two
So I can feel anew.

I'm tired of this volley
Pelting me to my folly.
I gotta get up,
Force myself to shut up.

I can take it on the chin,
Even give a grin.
But it doesn't fucking stop,
Even when I drop.

Why am I pretending?
I know this is my ending.
. . . but I just need a breath
Before I reach my death.

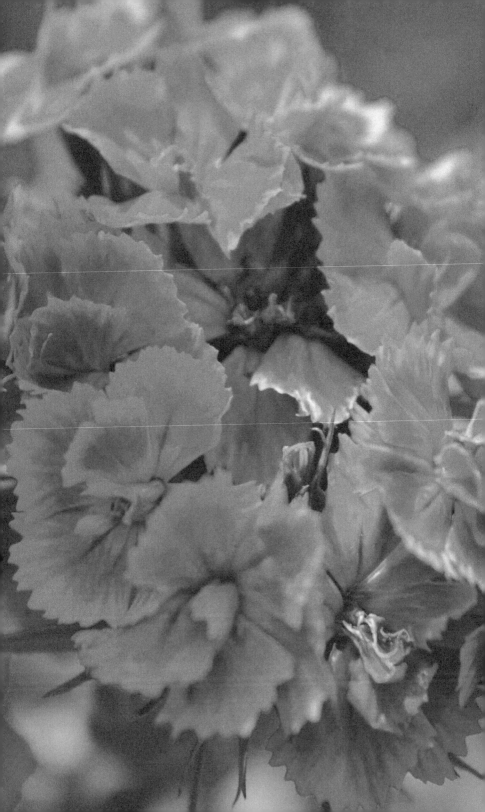

Forget My Knots

Knots hanging from my wrist
Hold the pains of my heart.
Silky cords with a twist
Keep the barrels just apart.

In the moments of my angst,
I caress these tiny knots.
Sighing a breath past the pangs,
Dreaded fears are soon forgot.

Strength comes

not from

fighting the storm,

but from

the embracing

and absorbing

of its power.

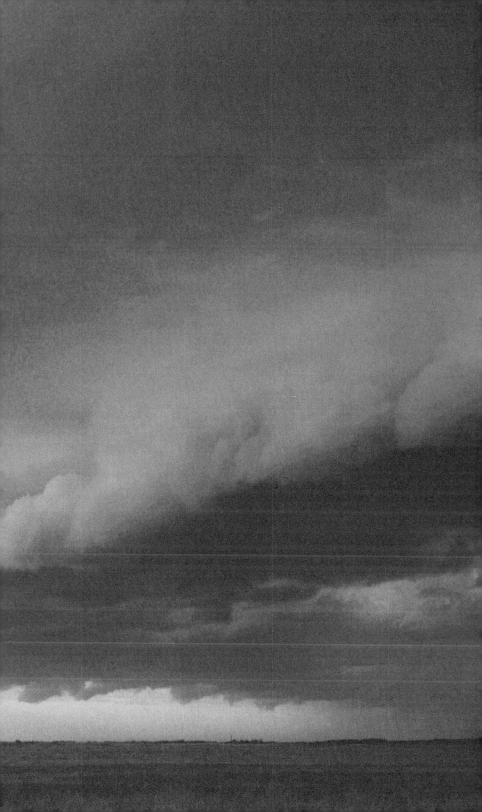

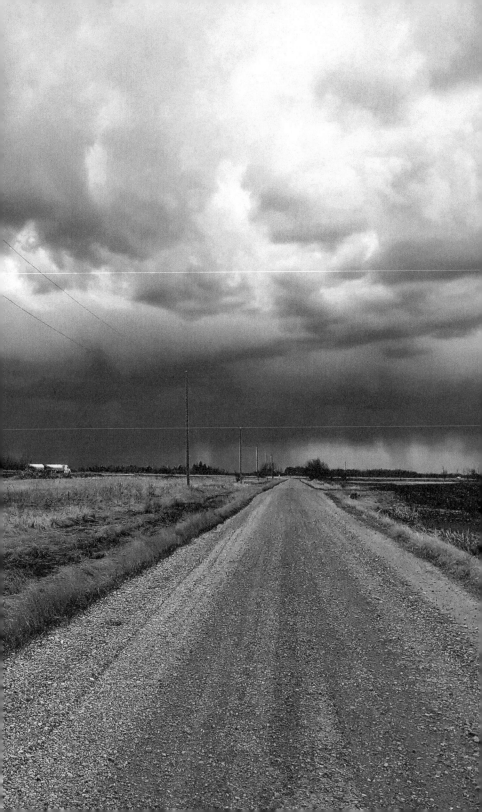

Storm of Transformation

The winds have permeated my thoughts,
Spinning and churning all my hurt.
I'm dragged this way and that,
Splintered, battered, and fractured.

Searching for an eye in this storm,
A calm to ease my mind.
Where is the voice of reason
To provide comfort as I stumble blind?

The gray clouds are spinning fast,
Swallowing me up whole.
I can't escape all the debris
Hitting me hard to my soul.

I'm drowning from the pelting volley
That is the rain of my own tears.
I am fragile and weakened, and
Desperately running from my fears.

I must find the courage deep within
To embrace this horrid storm.
I will plant my feet firmly down,
Root myself and be transformed.

There is a
never ending
of new
beginnings
each and
every day.

Dawn of Hope

Alone in the dark waiting for words,
Wondering why I feel so absurd.
I want to write but I feel stuck,
Mired down in nothing but muck.

Searching for answers for how I feel,
But living in fear is my new deal.
I hate it all, and I hate this day.
I hate myself for feeling this way.

Over the edge is a hint of light,
Giving reprieve for the long, dark night.
Streaks of color shimmer the sky.
I hold my heart and start to cry.

At last, my words begin to flow,
Comforting me more than I know.
A new day dawns, giving me hope,
Inspiring my soul to help me cope.

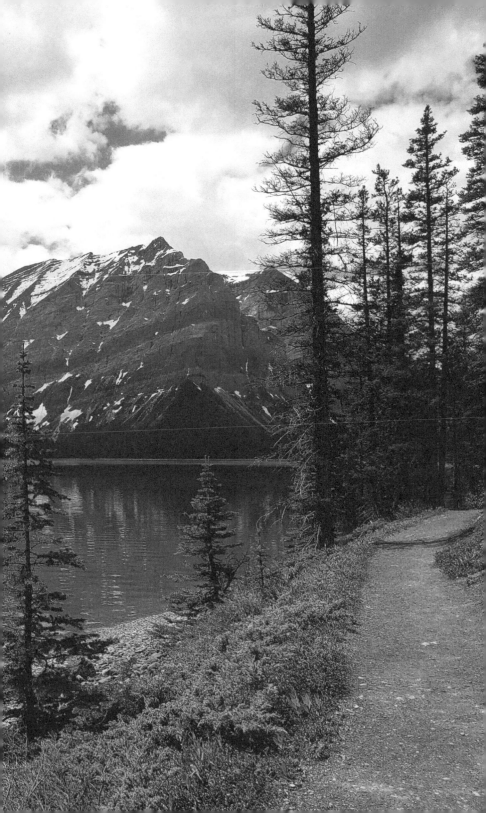

The Choice is Mine

On the road to finding me,
I feel more lost than before.
Awareness took its hold,
And I can't get anything more.

I see where I want to be,
But obstacles are in my way.
Will my life ever change?
Will I ever be okay?

Was the former me better?
There's nothing about her I miss.
Yet here I am believing
That ignorance is really bliss.

I've decided to keep on this path,
Knowing the choice is truly mine.
The road ahead will be tough,
But I promise I will be just fine.

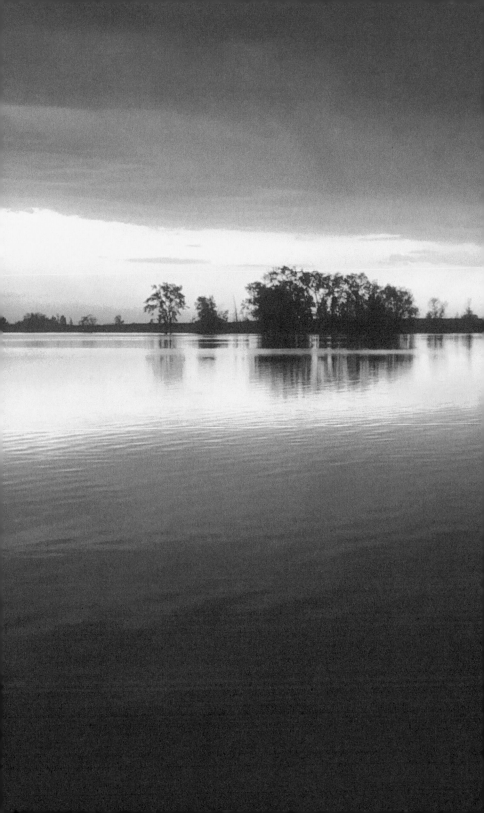

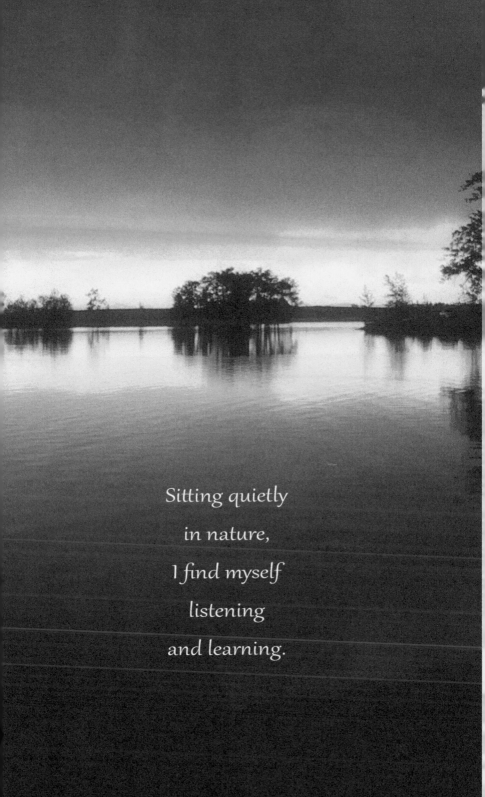

Sitting quietly
in nature,
I find myself
listening
and learning.

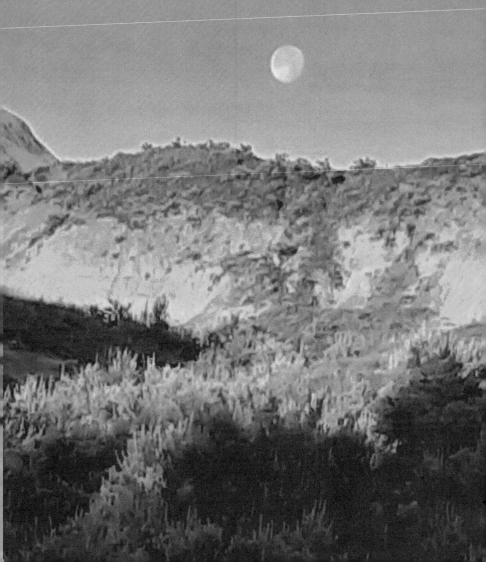

I must phase
as the moon
if I am to become
whole again.

Moon of Intrinsicality

Hearts of beasts pound,
Crying a devoted praise,
An eerie howling sound.
To you their voices raise.

Waters of deep pulsate,
Rhythmically draping the shore.
Pulled to you as its mate,
Breathless and panting for more.

Strength of man grows weak.
Crazed minds driven mad.
Creatures dreamily sleep
Until enough has been had.

Time limits your power,
Shining beacon of night.
Pacing darkness by the hour,
Abandoning me by first light.

Lightning

Lightning strikes across the sky,
Coursing from cloud to cloud,
Illuminating all its tears,
Lifting a forbidden shroud.

It begs and cries to be heard,
Never fully understood.
Wielding its power far and wide,
Seen as bad but wishing good.

Feeding the soil and plants,
And giving energy to the ground,
It does mankind a great service
So that we may flourish and abound.

The Colors of Light

Magnificent brilliance of Light,
You shine your colors so bright.
Separately they have shone.
Coming together, they are as one.

From the green of the trees
To the yellow of the bees,
Shades of warmth and of the cool
Manifest themselves in this earthly pool.

The meadow of pink over yonder
Causes one to traipse and wander.
White shapes above fly by,
Against the blue backdrop of the sky.

Magnificent brilliance of Light,
You shine your colors so bright.
Separately they have shone.
Coming together, they are as one.

When darkness falls creating bleak,
Grey blurry images come to sneak.
Chaos and nightmares set in.
Beauty is gone and all is grim.

A strike of lightning itself seeds.
The only color now is red that bleeds.
Death and destruction are what is left.
Without color, the world is bereft.

Magnificent brilliance of Light,
Your children are hiding; they are in plight.
Separately they had shone.
No longer together, they have all but gone.

Magnificent brilliance of Light,
Bring your children to the fight.
Separately they are all alone.
Coming together, they will be as one.

Tears fall and wash the ashen blood.
Fresh colors arise from clay and mud.
Green, yellow, and pink abound.
Victory song is the only sound.

Light presents a gift, a truth.
A prism appears arced in blue.
Each color defined, yet bending to its brother,
Humbly bowing to Light as its mother.

Magnificent brilliance of Light,
You shine your colors so bright.
Separately they have shone.
Coming together, they have won.

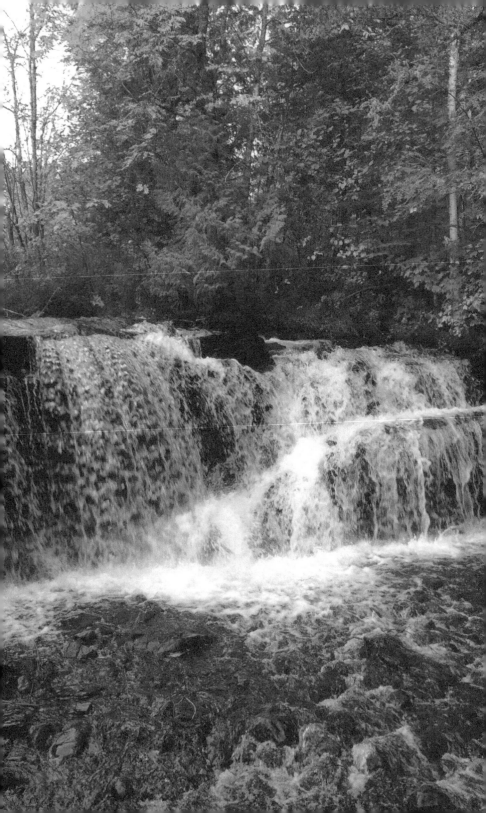

Aging Leaves

Vibrant red leaves mixed with orange and gold
Are as a coral sunset late in the day.
Time is short, feeling the blanket of cold,
Desperately hoping to keep winter at bay.

A medley of colours with a view to be sure.
Reflection shows their wisdom and grace.
Visited by many, the young and the pure,
They hope to be remembered and not be erased.

The days get crisp with a breezy blow.
One by one they fall to the ground.
Dancing in the air with an ebb and a flow,
Peacefully surrendering without a sound.

Never forgotten. No, never lost.
Something left behind remains to be seen.
It wasn't an end, but just a brief pause,
A new generation. A beautiful, vibrant green.

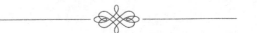

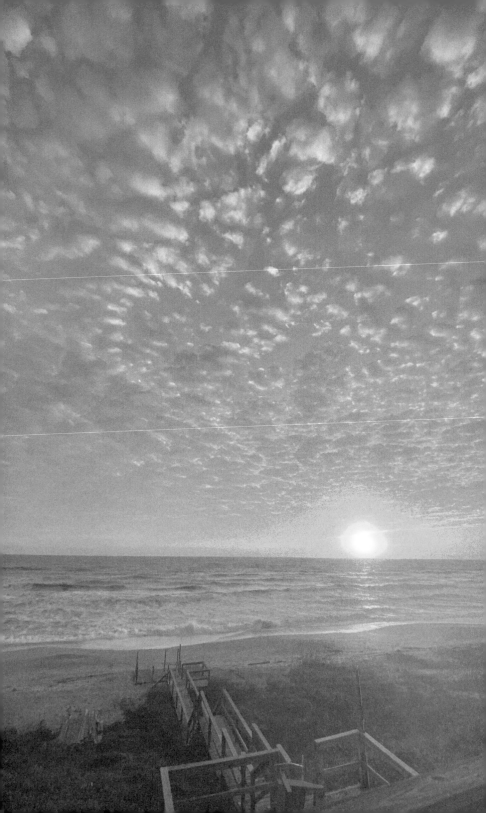

Cotton

Bits of cotton feathered across the blue,
Finding their way to the warm.
To a fire that rules and beckons,
Not as one, but as a swarm.

Above the water that breathes,
They release their tears.
But the fire gives them back,
Dispelling all that fears.

All things come together—
The blue, amber, white, and grey.
Thoughts and feelings merge
As I watch the cotton sway.

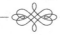

I am led to a

horizon of light

that is healing

to my soul.

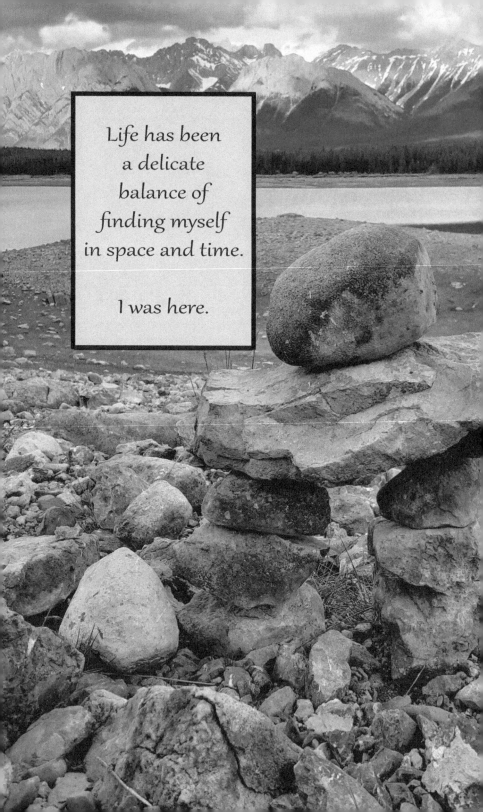

Life has been
a delicate
balance of
finding myself
in space and time.

I was here.

The Mutter of Clutter

In my mind is a cacophony of noise,
Making it difficult to sit quietly poised.

I close my eyes and try to breathe,
But the anger I feel causes me to seethe.

I try again, taking a deep breath.
Oh my God, this is worse than death.

Breathe in, breathe out. Breathe in, breathe out.
The vehement scream turns to a shout.

I power through, but peek at the time.
Halfway there. I might be fine.

A vision appears. It is a messy room
With boxes and folders all astrewn.

All that noise was from the clutter
That was speaking from one to the other.

I put things away, each in its place.
Everything is quiet, with a moment of grace.

The timer rings and I open my eyes.
The mutter of clutter has finally died.

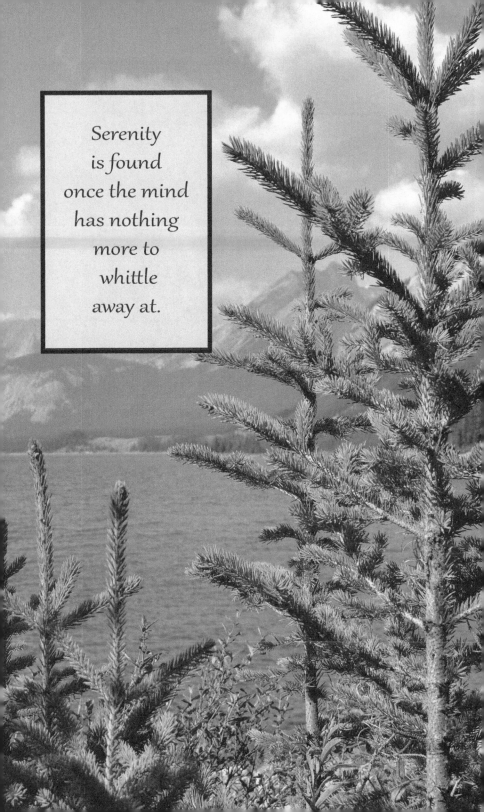

Serenity
is found
once the mind
has nothing
more to
whittle
away at.

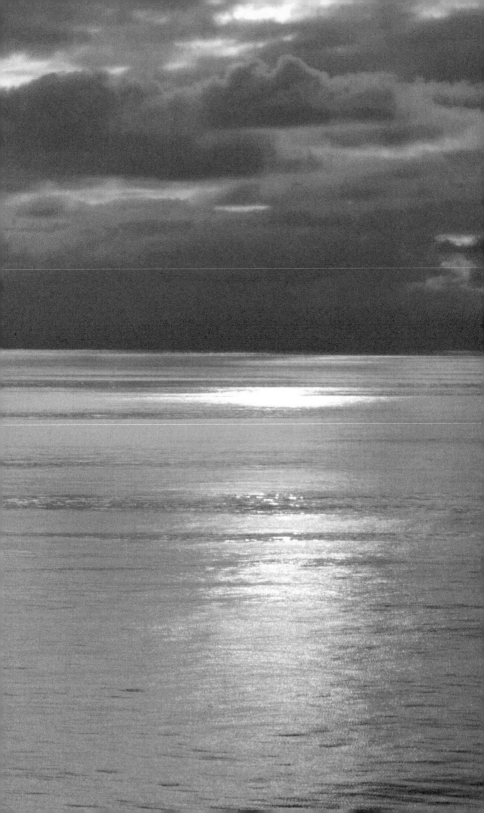

The Journey

There was a time I was drowning,
Thinking I would surely die.
Submerged deep below the surface,
Searching for answers as to why.

It was the search that was killing me—
The constant thrashing and gasping
Stealing my strength, and of
Breaths I could barely bring.

When I finally hit the bottom,
I grounded myself with my feet.
Then gave one last push,
Propelling up from the deep.

I no longer struggled, but
Let the momentum carry me,
Observing along the way
The wonders of the glassy blue sea.

I saw things not seen before
When I had been fighting so hard.
Beauty and creatures of marvel
I magically came to regard.

I learned to embrace my pain
And go along with the flow.
Understanding it wasn't a race
Because sometimes journeys are slow.

Upon reaching the surface,
The air was nourishing and sweet.
I'm energized with new life,
And I finally feel complete.

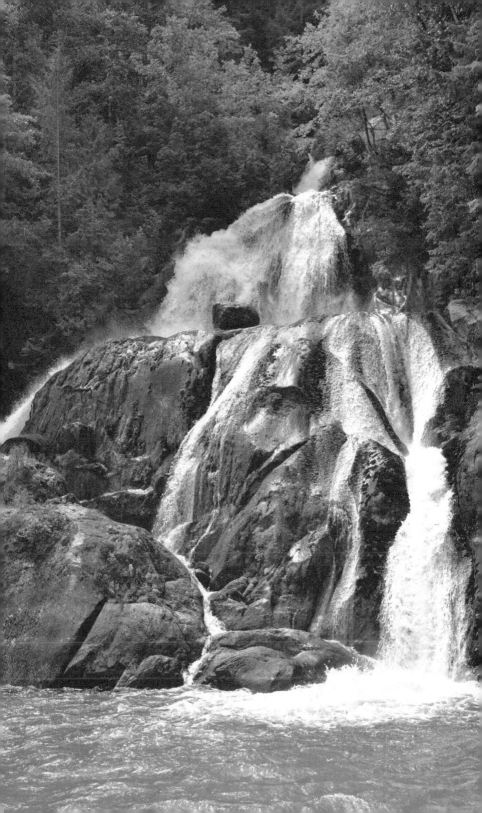

The path ahead
propels us forward
to a version of us
that is stronger,
better.

The View Ahead

I take a step. I take two.
Focusing my eyes on the view.
The beauty ahead quickens my pace,
Feeling the sun kissing my face.

My joy is strong. My walk is proud.
I giggle a laugh, silly and loud.
Excitedly, I begin to run,
Singing, "Life is good. Life is fun."

A hill from nowhere, in my way,
Grows on my path in just one day.
Steep with rocks and tangling grass,
No longer can I see my clear path.

I fall down and tumble far.
In darkness I fumble, searching for a star.
A cloud passes and it shines bright.
My path I see from its clear light.

The hill is gone, blocking no more.
I stand ready, strengthening my core.
I take a step. I take two.
Focusing my eyes on the view.

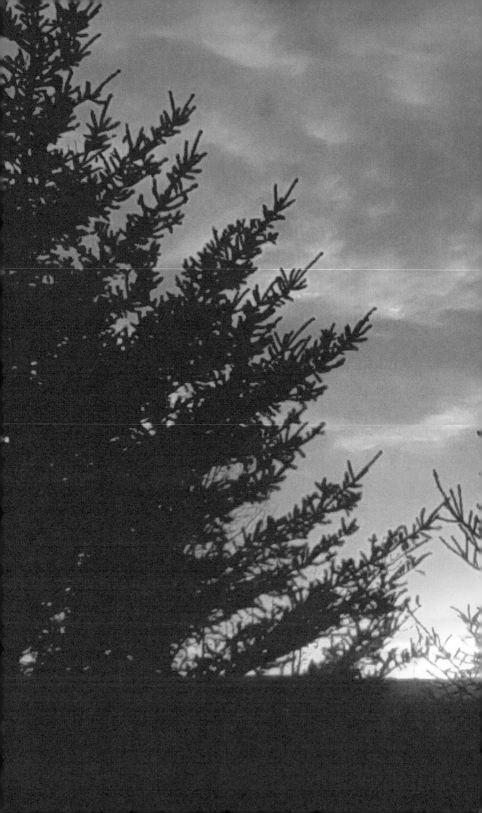

If we are to

claim our destiny

you must also

heal and grow,

and learn to trust,

once again.

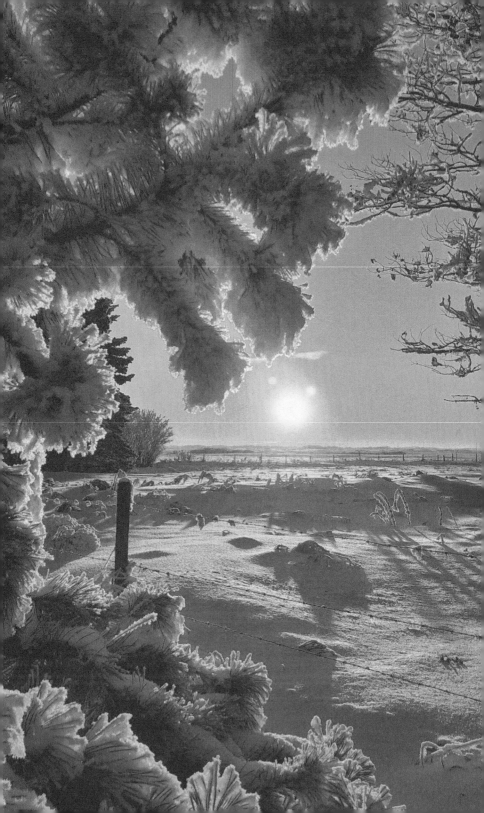

Safe Haven

Forsaken memories haunt
From a time so long ago.
They bubble to the surface,
Bringing sadness and woe.

You wonder if you're safe
In a world full of hate,
And glimpse to the future
For a view of your fate.

As the dark bird portents,
A path it does reveal.
For a change is coming;
The souls of two will seal.

Your demons will be conquered,
As told by the raven,
For you will find your true love—
Your anchor and safe haven.

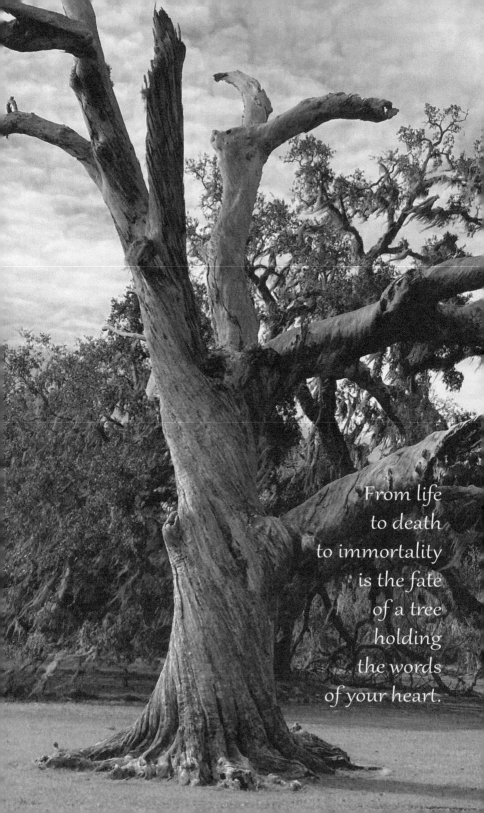

From life
to death
to immortality
is the fate
of a tree
holding
the words
of your heart.

Bound Books

Leather and lines hold the words
From the deepest part of your heart.
All alone in the still of the night,
Piecing the life that's torn apart.

Secretly kept for your eyes alone
Until the time she can receive
The love you hold so tight,
Giving you relief and reprieve.

Bound books fill your shelves
With nowhere else to go.
But soon for the grace of God,
Of you she will come to know.

Love will fill her very being,
And you will no longer mourn
As you read to her what's been written
Since the time she was born.

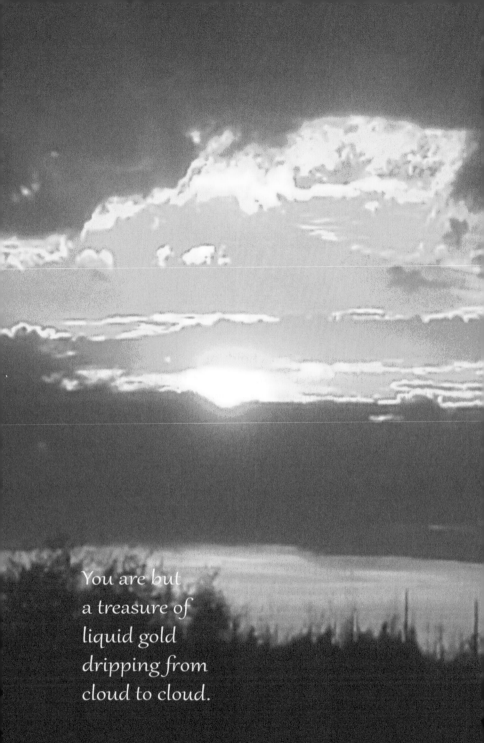

You are but
a treasure of
liquid gold
dripping from
cloud to cloud.

Silhouette

You've been hiding from the light,
Enveloped by the black of the night.
But there's a beauty that blooms in the dark,
And your silhouette has left it's mark.

You can't escape who you are.
Your contours are of a gleaming star.
A lit edge as a subtle beacon,
With a portal that leads to a safe haven.

It's time to set your silhouette ablaze,
And let the world wonder in amaze
At the beauty that has grown
Into something they've never known.

For while they slept in the dark,
Your silhouette left its mark.
From this eclipse you will shine
To a grander place of your design.

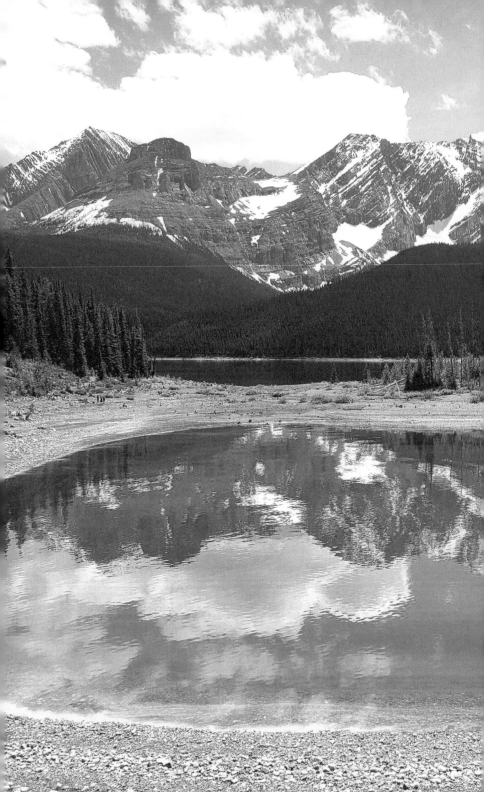

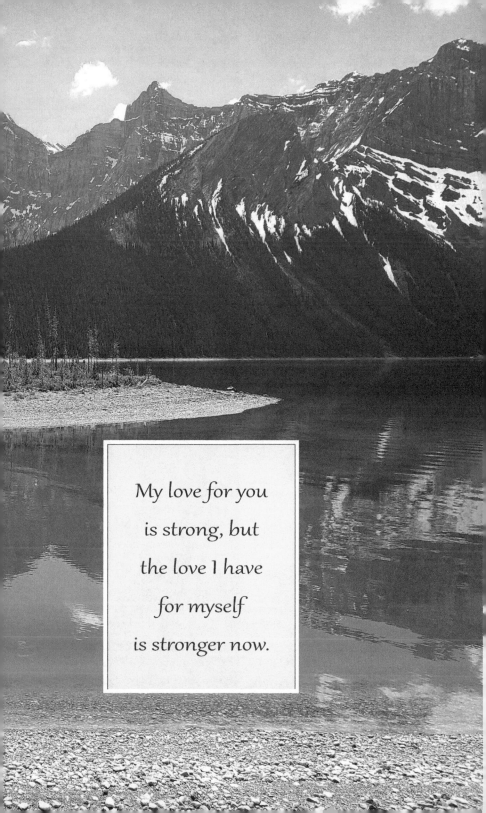

My love for you
is strong, but
the love I have
for myself
is stronger now.

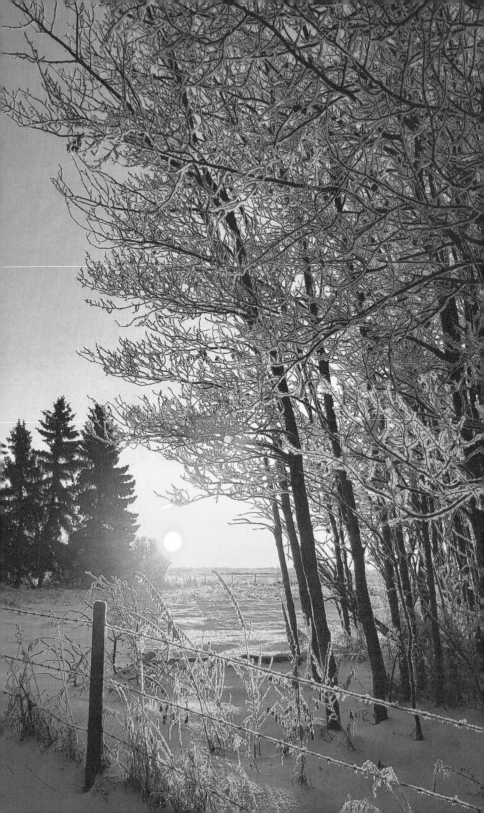

The Day I Was Born

My clock stopped the day I was born.
I've lived a life that should not have been.
The world continued, yet time stood still,
For I'm a memory of a horrible sin.

I am reminded of things like:
What doesn't kill you makes you strong,
And, it's not where you come from,
But rather, where you belong.

Time stood still the day I was born.
I've lived a life created from sin.
The world continues with or without me,
And all my strength comes from within.

I spend my days helping others
Because I love people and truly care.
It gives purpose to my life,
And fills me with kindness rather than despair.

TAMMY RÉBÉRÉ

My world began the day I was born.
I'm living a life that is meant to be.
There is not enough time in the day
To extend all my gratuity.

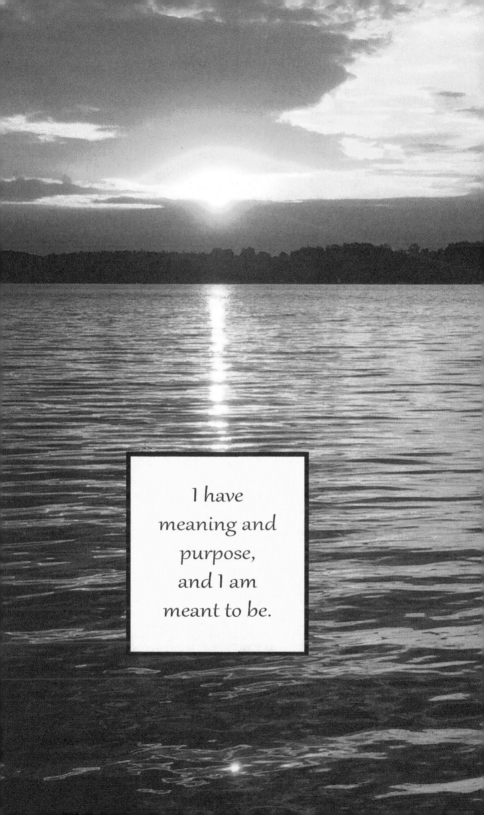

I have
meaning and
purpose,
and I am
meant to be.

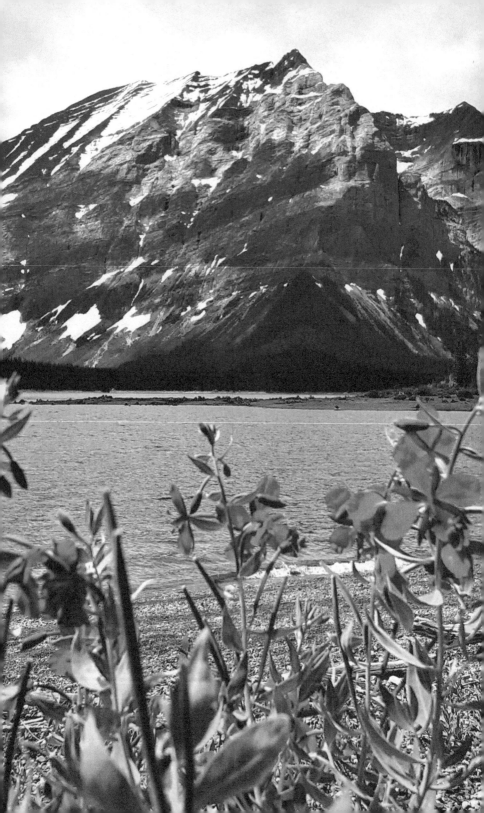

Searching

I have been searching
For the meaning of my life.
From madness I was born,
And a childhood filled with strife.

Hiding under beds
From the demon that haunted me,
Yet always told
My purpose was yet to be.

Looking to my wall
For heroes to give me power,
I masked my fear and innocence,
Never be seen to cower.

I have been searching
For a meaning of my own.
Hoping to help others,
Give a path I was never shown.

Alone in this world,
I find comfort in nature's source.
The sun, the moon, the stars
Help steady me on my course.

Energy for my soul
And a light in the dark,
Give me the strength I need
As my path I embark.

Searching, searching, searching
For my meaning, my purpose.
My fingers can almost touch it.
I know that I am close.

Walking along the waters
With a crescent moon in sight,
A hand reaches out,
Saving me from my plight.

A mission we share:
To walk with open arms,
Helping all the others
In this world that have been harmed.

I am still searching,
But my purpose I now see.
My search is to find all those
That are just like me.

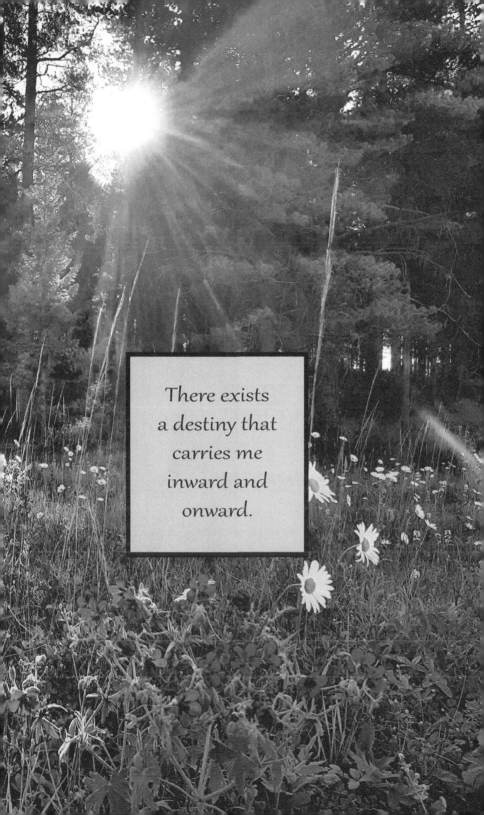

There exists
a destiny that
carries me
inward and
onward.

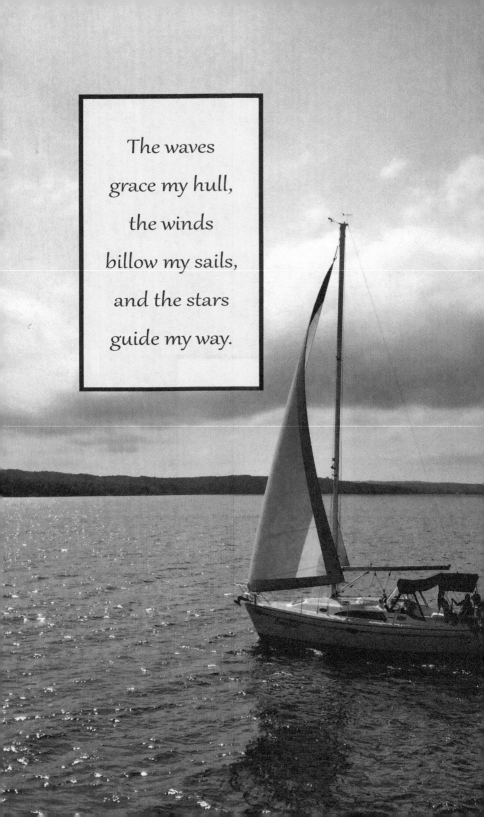

The waves
grace my hull,
the winds
billow my sails,
and the stars
guide my way.

The Ketch

Her beauty and strength were unsurpassed.
From pillage and plunder her materials came.
White was her sail with a spinnaker to match.
Stolen was she, but not to blame.

Her captain was cruel, sinking most ships,
Treating them harshly against the waves.
The floor of the ocean was but a crypt,
Abandoning others along seaside caves.

On open water she passed his test.
Her grace and speed made him smile.
He kept her special as his best,
And loved her deeply for a while.

Unable to change and true to form,
He abandoned the ketch to the roaring sea.
Lost in the dark, amidst a storm,
She stayed with the current, under the lee.

Days came and days passed.
She wandered the waters all alone.
Gliding along the deep blue glass,
Flecks of diamonds she was shown.

She made her way with dolphins as friends.
Swimming and dancing, they played about,
Discovering treasures around the bend.
Shrieks of joy, they did shout.

A pirate saw the ketch as he lurked the shore;
A new course for her, he would chart.
His greed and darkness he could not ignore.
Killed the dolphins and broke her heart.

She was loved and hated just the same.
Her spirit had broken from abuse.
She drifted along toiling with shame.
Her hull was empty and of no use.

She left the pirate by way of the tide,
Letting it take her far away.
Sad and alone she many times cried.
From all that was good she did stray.

The sea of blue had turned to black,
Filled with sharks that wanted her harm.
Nowhere to turn, she let them attack.
Nothing to help her, not even her charm.

She mustered herself and straightened her keel,
Letting it guide her as she slept.
With rest and strength, she began to heal.
Handling the harsh sea, even at great depth.

A kind caretaker she came to know.
He loved her truly, deeply, and strong.
Sheltered her from the wind's fierce blow.
Never let her forget that she belonged.

Many a storm together they faced.
Laughed and reveled when it was calm.
She never knew such love or grace,
Sailing about with her helm in his palm.

I remember you said,
"Don't go falling
in love with me."

I did anyway.

I never stopped.

Footprint in the Sky

Conflicted and troubled with a dilemma in mind,
I walk after the rain to enjoy the sun's shine.
The cool breezy air after the muggy damp heat
Is what my soul needs to make my impassioned plea.

"Do I go this way or that?" I call to the air.
But who am I summoning? No one is there.
My mind tells me, everything in its season.
Yet the pounding in my heart says, everything has a
reason.

How do I know? What shall I do?
My beliefs are mixed and I need some sort of clue.
I cry for a sign if I am to walk with my heart.
And if nothing happens, my mind will be my chart.

I look up at the sky and see a foot in the clouds,
With a prism of colors holding it firm and proud.
My heart I should follow is what it's telling me.
Now I know some things are just meant to be.

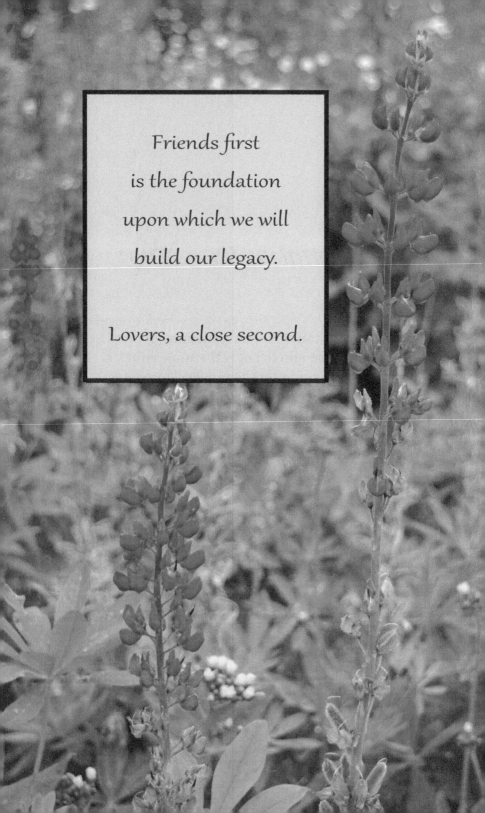

Friends first
is the foundation
upon which we will
build our legacy.

Lovers, a close second.

I'm Here

Today I cried to a friend.
He said, "I'm here. Just breathe."
To my breath I did tend,
And heard him breathe with me.

A tear fell upon my cheek.
He said, "It's okay. I'm here."
My heart felt a little less bleak,
And I soon let go of my fear.

My concerns I finally shared.
He said, "I'm here. I'll aid."
I knew that he really cared,
And my sadness began to fade.

Upon my lips came a smile.
He said, "I'm here. Always."
But that I felt, all the while,
And I was glad for him this day.

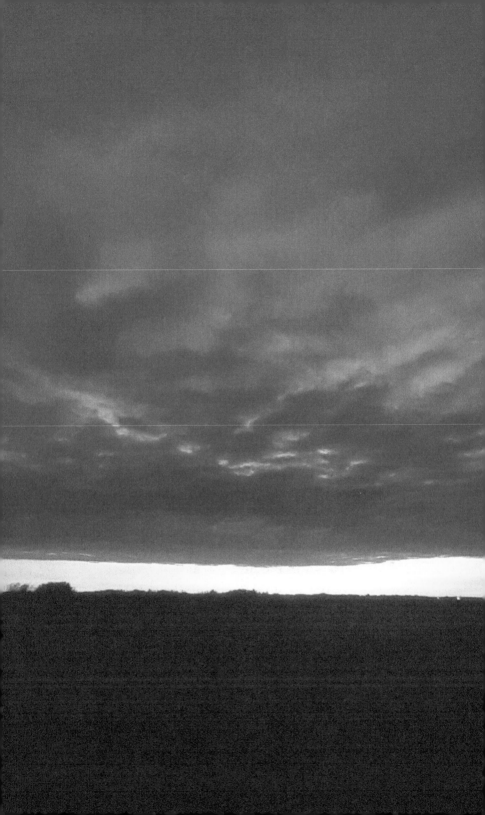

Whole

Alone in the dark for most of my life,
Calling out just to be heard.
The light could not reach for all my strife.
In darkness I stayed, waiting for a word.

Wishing for silence from all the voices,
Yet not wanting to be alone.
Wishing I had made different choices,
Yet the decisions were all my own.

Many times I reached out my hand,
Yearning for a gentle touch.
But all I received was reprimand.
It had all become just too much.

But all that led me to this moment,
And I would repeat every single one.
'Cause now I know nothing's by accident.
I know what it's like to have truly won.

When I realized that you are my destiny,
I relinquished what I thought I controlled.
You saved me from my all agony,
And now I finally feel whole.

We are the sky

and the water,

destined to meet

at the world's edge,

leaving a fiery trail

in our wake.

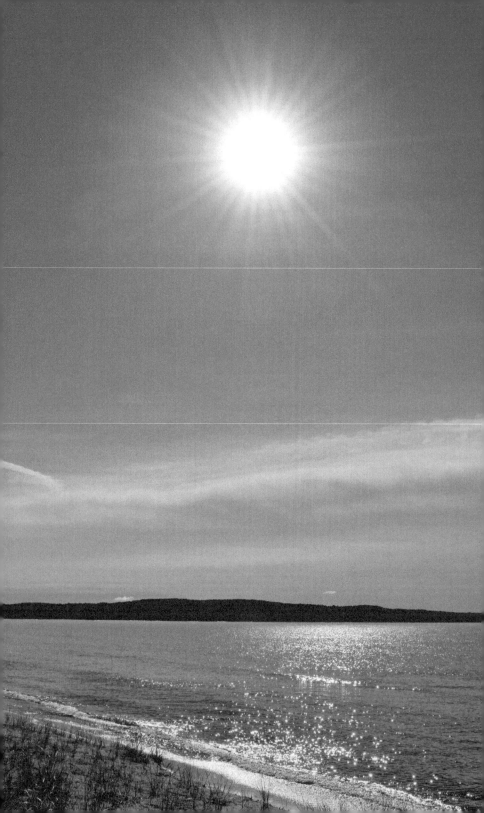

The Elemental Secret

Pulled by gravity yet reaching for the light,
The tides of the ocean share my plight.
Watching the waves pulsate their roar,
I breathe the salt air along the shore.

My thoughts are deep and quite heavy.
They hold my course, strong and steady.
The ground's charge threads my veins,
Yet firm I stand without disdain.

Light and airy becomes my heart.
Happiness fills my every part.
Tickled I am by a gentle breeze.
A gesture of love? If you please.

With eyes that glow and brightly shine,
I face skyward, feeling sublime.
Kissed softly by the great fireball,
I stretch myself high, ever so tall.

My cheeks cool by a passing cloud.
Rain falls down, lifting a shroud.
Cleansed to the core, I am pure.
My soul will flourish and endure.

The sea is now calm. Its breath is light.
Wet graces my toes and I feel delight.
A secret I learned standing on this sand:
I am one with the sea and one with the land.

Within me, I hold all of the elements.
I am the child of grand benevolence.
Earth, wind, fire, with a splash of rain,
Beholden I am, and to that I remain.

I am the sand—
kissed and tickled
by the
ocean's breath.

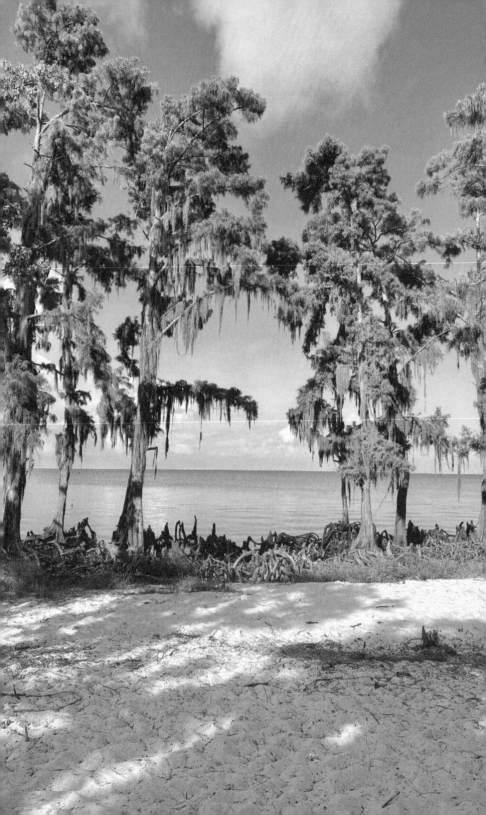

Here and Now

From dreams long ago in a faraway world,
Words once forgotten flow from my heart.
You bring love and joy that has long since lapsed,
And this healing in my life is just the start.

Colored music surround the soft whiskered trees
By the shore of our hidden crescent beach.
With the gentleness of your tender touch,
The future I've seen is within our reach.

Our lives have been entwined for a millennium,
And thousands more yet to come.
Finding one another through great peril,
But it is here and now we build our kingdom.

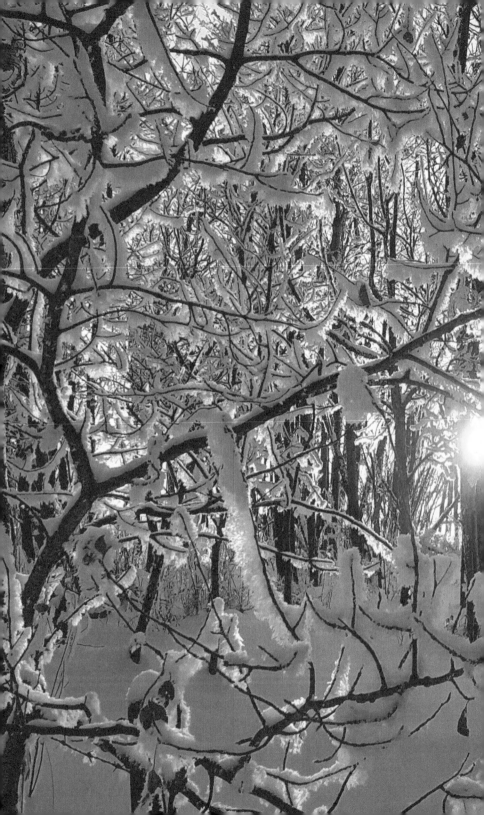

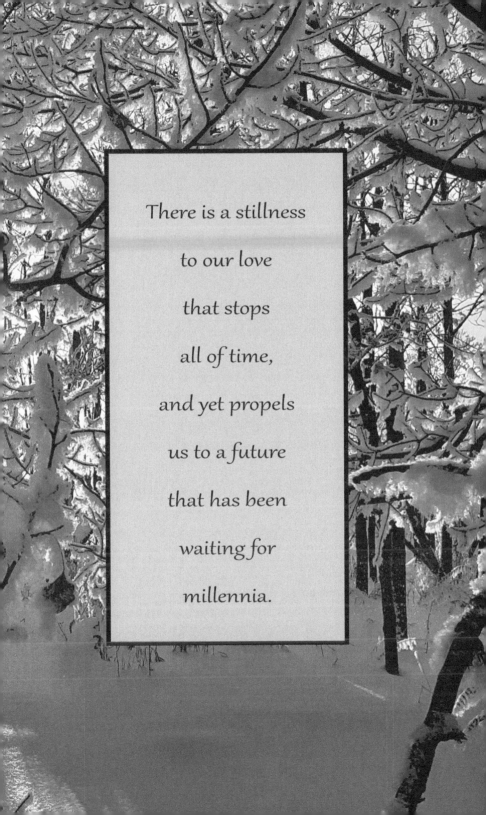

There is a stillness

to our love

that stops

all of time,

and yet propels

us to a future

that has been

waiting for

millennia.

Out of the
shadows of the night
and through the
eclipse of our love,
we found each other
once again.

We are tethered,
and our
souls are entwined.

I love you, my darling.
Forevermore.

ACKNOWLEDGMENTS

Intense emotions are most often what precipitates poetry, at least that is the case for me. I have spilled my words onto the pages of this book from the out-pourings of my heart and soul—my deep-seated feelings of love, passion, sadness, grief, loss, guilt, and even shame.

Intense emotions, indeed! Am I grateful for the events that led me to experience all of those feelings? Yes, I suppose I am, because I've learned and grown, and I believe I'm a better person for it all. I am thankful for my struggles and triumphs, for the good and the bad decisions I've made, and for the people I've loved and lost—we have crossed paths for a reason.

The photographs that accompany the poems also have profound meaning in my life. They are more than moments captured in time. They are a testament to my existence. *I was here!* They are intimate moments

between the glory and splendor of this earth and me. *I am worthy!* They are reminders that it's a new day with new beginnings. *I have purpose!* For these life affirmations, I am thankful.

Thank you to my husband, Glenn, for the camera you bought me all those years ago and the encouragement to take photography lessons. I see the world differently now.

Thank you, Terry Leeder, my former mentor and editor. Since your passing, I have been missing you beyond belief. I hope I make you proud.

Thank you, Christian, my dear friend and mentor. You inspire me every day to be better than I was the day before. I am grateful for your constant encouragement.

Thank you to my friends and family, especially Charlene Fleck, your constant support and belief in me helps me believe in myself. Also to Dan Trisevic, Kristina Shelden, Lauri Schoenfeld, Peter Debaere, Levi Debaere, Pam Paradis, and Melanie Holland, as well as my incredible writer's group at the Creative Academy for Writer's, gratitude doesn't even begin to describe the feelings I have for you all.

And thank YOU, the reader, for without you, poetry would cease. Books would cease. Keep reading and loving poetry!

Made in the USA
Monee, IL
24 July 2023

39573212R00111